Me and My CAMERA 2

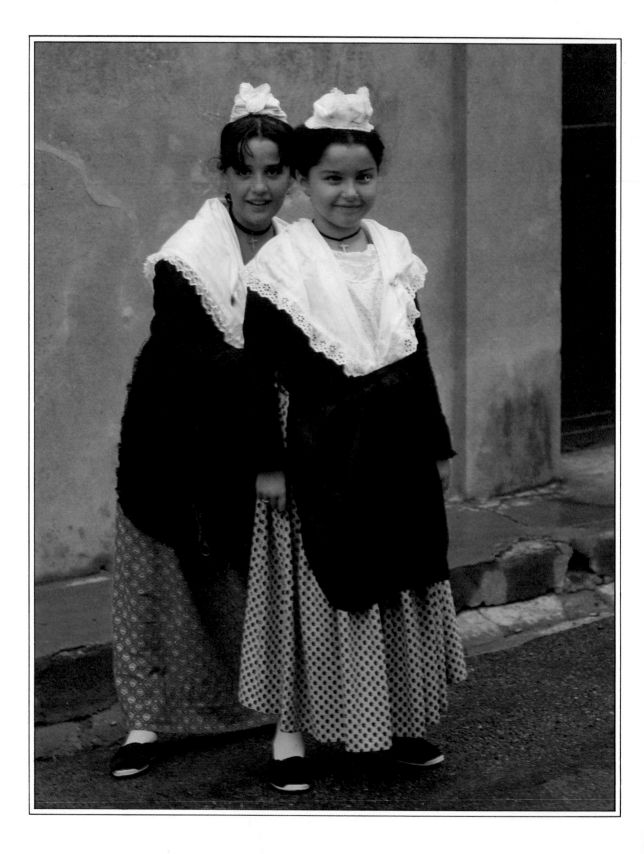

Me and My CAMERA 2

JOE PARTRIDGE

COLLINS
8 GRAFTON STREET, LONDON W1
1983

TO GEORGE EASTMAN (1854–1932)
WHO BROUGHT PHOTOGRAPHY TO EVERYONE

William Collins Sons and Co Ltd
London · Glasgow · Sydney · Auckland
Toronto · Johannesburg

Partridge, Joe
Me and my camera 2.
1. Photography
I. Title
770'.28 TR146

ISBN 0 00 217069 8

First published 1983
© Yorkshire Television Enterprises 1983

Designed by Janet James
Set in 10 on 11 point Monophoto Apollo
Made and printed in Great Britain by
William Collins Sons and Co Ltd, Glasgow

CONTENTS

INTRODUCTION

More and more people now realize that they can get better results from a camera without having to make photography a hobby, let alone a profession. In the original *Me and My Camera* series Yorkshire Television used the special knowledge of experienced professional photographers to explain the basic techniques needed. The success of *Me and My Camera*, both as a television series and as a book, has led to a second series and to this new book – *Me and My Camera 2*.

Me and My Camera 2 goes a little further in subject matter and in terms of the techniques explained; none the less all the subjects and many of the techniques can be tackled with even the simplest cameras.

There are six sections to the book. **The Great Faults** looks at the main mistakes people make with their pictures, and shows how to correct them. The number of cameras and other equipment on the market has made buying a camera an ordeal and the **Buying Guide** shows you what to look for when buying any equipment. The third section, **Techniques**, goes to some lengths to explain fill-in flash and close-up photography, as well as photographic special effects.

The **Subjects** are explained in the series by another team of well-known photographers: Anthea Sieveking on babies; Eamonn McCabe on indoor sports; Patrick Lichfield on groups; Tony Evans helps with taking pictures in bad weather; and David Bailey looks at landscape in towns. Close-up techniques are examined from several points of view, with Heather Angel explaining how to use it with nature subjects and Michael Langford, the series adviser, demonstrates special effects. George Hughes, my co-presenter, and I tackle telling the story of a day out. Looking at pictures when you know how they were taken is the best way to improve your own photography, and those taken by the series guests, together with the other examples here, will give you the means to improve your own results.

Displaying your Pictures is full of tips on how to show off the results of your new skills as effectively as possible. **Developing and Printing** explains in simple terms the delights to be had if you process your own pictures.

Michael Langford is a Fellow and Senior Tutor in Photography at the Royal College of Art in London, as well as being a prolific author of books on photography. For over twenty years he was a busy professional photographer before devoting himself to photographic education. He has been the technical adviser to both series of *Me and My Camera*.

Anthea Sieveking is a busy London freelance photographer. She works on editorial assignments for magazines covering all manner of subjects, but for her own work she specializes in pictures of children and parents. She tries to keep her equipment simple and, when possible, to take all her pictures using available light.

Michael Langford.

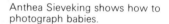

Anthea Sieveking shows how to photograph babies.

Eamonn McCabe is a staff photographer for the *Observer* newspaper; he began taking pictures for local papers before gravitating to Fleet Street. A keen sportsman himself, he works almost exclusively on sports assignments and travels all over the world taking pictures. He has a soft spot for the less fashionable sports, which made him a natural choice for illustrating indoor sports as a subject. Although as a top sports photographer he works with a whole range of equipment, his style is very simple and graphic and he often includes humour in his pictures. He has won the Coveted 'Sports Photographer of the Year' title three times.

Patrick Lichfield. After working as an assistant to several top London photographers in the early 1960s, he set up on his own. Initially he worked for fashion magazines; later he broadened his range and now undertakes photographic assignments all over the world that encompass fashion, beauty, glamour, reportage and advertising. His photographs of the wedding of Prince Charles and Lady Diana Spencer were seen all round the world.

Tony Evans has two careers: he is a much sought-after advertising and reportage photographer with, amongst others, the photography for several Benson and Hedges advertisements to his credit; and he is

Joe Partridge used laser technology for this surreal study of a chemical works for *Woman's Own*.

Eammon McCabe photographing fencers for the Indoor Sport programme.

David Bailey went to London's dockland to photograph urban landscape for the television series.

Assignments for the *Sunday Times* are part of Tony Evans' busy work schedule.

a skilled natural history photographer. For nearly twenty years he has been among the top editorial photographers in Europe.

Heather Angel trained as a biologist and took up photography only when she could not find suitable pictures to illustrate lectures. She has now become world famous, with her pictures being used as examples of the best in nature photography. Her recent work has involved travelling tens of thousands of miles to illustrate the varied flora and fauna of the world.

David Bailey made his name in the 1960s as a fashion photographer, but that now represents only a small part of his work. He is simply totally in love with photography. Working seven days a week, he has

Patrick Lichfield photographed people in both series.

published pictures of landscapes, nudes, reportage and portraits and also finds time to direct films and commercials for television.

George Hughes is the editor of *Camera Weekly* – the fastest-growing magazine for the photographic enthusiast. He worked as a freelance photographer before joining the staff of *Practical Photography*, then from there to be the features editor of *Amateur Photography* before taking over *Camera Weekly*. He still finds time to write numerous articles and books on photography as well as to take photographs – especially in his beloved Scotland.

The whole world of nature is photographed by Heather Angel.

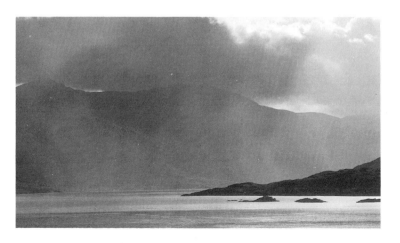

This storm in the highlands of Scotland was captured by George Hughes.

THE GREAT FAULTS

LOADING THE FILM

If the whole of your film is like the examples here, with the maker's edge-lettering showing, it is probable that the film has not passed through the camera. This is due to incorrect loading. You would get the same results if you left the lens cap on a compact camera for the whole film.

The time to learn how to load a camera is when you buy it. Don't get it done for you: ask the assistant to show you. When you get home read the instructions carefully, rehearse each step, then load the camera yourself.

110 and 126 cartridge cameras and disc cameras are very simple to load because the film will only fit in one way, but make sure that the back is firmly closed after loading. Most problems will occur with 35mm cameras.

Unexposed negatives.

Unexposed transparency.

35mm SLR and compact cameras

Re-wind your film by depressing the clutch and, using the re-wind handle, slowly wind it back into the cassette.

When the handle turns freely open the back, remove the film and put it somewhere cool and safe.

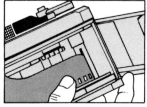

Put the new film cassette in the camera with enough film already pulled out to reach the winder-spool. Slot the leader in, ensuring that the lower sprocket holes engage.

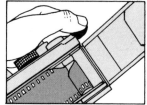

Wind on the camera (you may have to fire the shutter each time) until both sets of sprocket holes are engaged. Now close the back, locking if necessary.

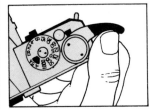

Fire the shutter twice to wind on the film for two full movements.

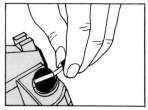

Gently turn the re-wind lever clockwise until you feel resistance.

Wind on one full movement, watching the re-wind handle. If it rotates, the film is correctly loaded. Check the ASA setting on the camera.

Auto-loading cameras

There are several types of self-loading camera on the market. Read the instructions carefully. If the camera has no re-wind handle it will have some form of visual indication of film movement. Watch these as the camera winds on to '1', to make sure that your film is correctly loaded.

HOLDING THE CAMERA

This effect was caused by camera shake.

Holding
The best way to hold your camera is with your elbows tucked in and the camera held firmly to the face. Squeeze the button gently.

If your camera moves, however slightly, when you take your picture, the result will be blurred.

You must hold any camera firmly to reduce the risk of movement. Stand with your feet apart so that you are well balanced. Hold the camera firmly to your face with your elbows pulled in to your side. Relax. Don't try to take pictures if you have just been doing any strenuous activity such as running.

Correct shutter speed is crucial for a sharp picture; if the low light warning in your camera is lit, or a speed of less than 1/60th is indicated, you will usually get some degree of blur.

If you have a telephoto or zoom lens for a 35mm SLR camera, the problem of shutter speed increases; you must treat faster speeds as your minimum for hand holding. With a 135mm, the slowest speed should be 1/125th; a 200mm needs 1/250th; 500mm requires 1/500th. These same speeds should apply to zoom lenses at the same settings.

When you have composed your picture you should gently squeeze the shutter release. It will often help if you can brace yourself against a solid object, such as a car or a wall.

Hand-holding
Whatever lens you use it will be virtually impossible to successfully hand-hold your camera at speeds slower than 1/60th.

The lens was obstructed by the camera strap.

Cases
Make sure your camera case does not obstruct the lens. This is particularly important with compact cameras.

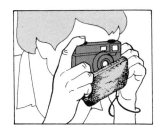

Obstruction

Any obstruction of the lens will record on the film, usually as a black mark.

Make sure that the lens cap has been removed, and that the case and strap are not in front of the lens; hold the camera so that your fingers don't obstruct the light sensor, or the flash if you are using it: either will incorrectly expose your picture. These problems should not occur with SLR cameras, since you can see through the lens.

EXPOSURE

Under-exposed. Correctly exposed. Over-exposed.

Colour negative film
These examples are the results you would get with colour negative film.

Colour transparency film
An over-exposed transparency will look very washed out; an under-exposed one will be too dense.

Causes

Wrong ASA speed: make sure the dial for setting the film speed is set to the correct ASA speed: on some cameras it is easy to knock it to another setting. Each time you load a film check that it is set correctly.

Exposure compensation dial: some automatic cameras have over-ride settings to compensate for difficult light. These should be set to 0 when not in use.

Conditions: there is sometimes simply not enough light to take a satisfactory picture.

Light entry through viewfinder: the meters on some SLR cameras can be affected by light coming through the viewfinder. This can happen if you hold the camera too far away from your eye; a rubber eye-cup will help. This problem may also occur when the camera is being used with the self-timer.

Contrast range: film cannot record extremely bright and dark subjects at the same time. If your picture includes both you must set your exposure for one *or* the other. This sort of contrast may also confuse your camera's metre: *see* below.

Brighter backgrounds
Brighter backgrounds, such as beaches or snow, with darker subjects, can cause your camera to under-expose. You should use a substitute reading.

Darker backgrounds
Darker backgrounds with lighter subjects can cause your camera to over-expose and you should use a substitute reading

Wrong metering: the built-in light meter in a modern camera senses the light coming through the lens and sets an appropriate exposure. To do this it assumes the need to produce a picture that will average out to a mid-grey. Some cameras give higher value to the light from the middle of the picture, but they all strive to make the same average exposure. In situations where your picture is not of average brightness the camera will make mistakes.

Substitute readings
Most difficulties in measuring an exposure can be overcome by holding your hand in the same light as the subject and measuring the exposure from it.

Making a correct exposure

You should calculate your exposure for the subject, not its surroundings. If the subject is darker than the surroundings, the camera will normally under-expose because it over-reacts to the brightness. For instance, if there is too much sky in your picture the meter will try to compensate for the extra light; photographs on bright beaches and in snow are also particularly prone to this. Where a subject is lighter than its surroundings, the meter will over-expose as a reaction to the overall darkness.

There are several remedies for these faults. Firstly, you must know how your camera sees the light. Most cameras have a centre-weighted meter that puts a higher value on the light from the middle of the picture. If you have this type, and you make the subject fill the viewfinder, you will get a more accurate exposure. But some cameras take an average of the whole view, which is harder to control. Whichever camera you have, you should learn how to fool the meter into giving you the exposure you want.

This is easier with manual cameras, where you set both the shutter speed and the aperture. If you hold your hand so that it's in the same light as your subject, you can take your exposure reading from it: fill your viewfinder frame with hand for the best results. If you are taking landscape pictures, you should take your exposure reading entirely off the ground.

There are three methods of over-riding automatic cameras. The simplest cameras have no over-ride facilities: to change an exposure you will have to *alter the ASA setting.* If your subject is against a bright background, change the ASA to a lower speed: set 25 ASA if you have loaded 100 ASA film. For a bright subject against a dark background, set a higher ASA: 400 ASA if you are using 100 ASA film. *Always remember to change the ASA back afterwards.*

The easiest method of compensating is a backlight button. If your subject is darker than its surroundings or against the sun, you press the button and the camera will automatically over-expose to compensate. However, backlight compensation is of no use with a light subject against a dark background, but you can use it for overall bright subjects like snow scenes.

More sophisticated cameras have a separate *exposure compensation control* that you can set to give you from +2 to −2 stops over-ride. Use the + settings for brighter backgrounds and the − settings for darker. *Remember to change it back to 0 afterwards.*

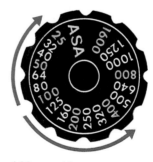

ASA over-ride
Set a lower ASA speed for brighter backgrounds and a higher for darker backgrounds.

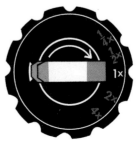

Exposure compensation
Set a larger multiplier for a brighter background and a smaller for a darker background.

FRAMING

This example demonstrates pictures where the subject is not placed as you saw it when you took the shot.

Framing faults can occur when the lens and the viewfinder are separate.

Causes

● Your eye is wrongly positioned in relation to the viewfinder. If you keep your eye too far away, too high or too low in relation to the viewfinder, you will get 'false framing'. Position your eye as close as comfortable to the viewfinder so that you can see all four of its corners.

● You have not allowed for parallax. This is the term for the problem of having the lens and the viewfinder separate, something which does not occur with SLR cameras. If the lens and viewfinder are separate as in most 110 and compact cameras, the closer you get to your subject, the greater will be the discrepancy between what your eye sees and the lens sees. You can get an idea of this by sighting an object close up, one eye at a time: the separate eyes cannot see the same image or you would go cross-eyed. Cameras with separate lens and viewfinder should have correction marks in the viewfinder. If your camera has not, place your subject slightly to the lens side of the viewfinder when closer than 6 feet to your subject.

Bright-line finder
Spectacle-wearers will find framing easier if their 110 and compact cameras have a frame in the viewfinder. The two stubby lines are for parallax correction.

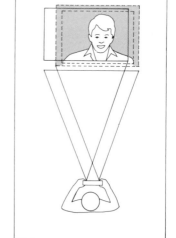

Parallax
With cameras where the viewfinder and lens are separated you must be careful with framing as the subject gets closer. Position your subject slightly on the lens side of the viewfinder.

Spectacles

The wearers of spectacles will face framing and focusing problems with most cameras.

With simple and compact cameras you will find that those with a bright rectangle outlining the picture area, called a *bright-line finder*, will be easier to use with your glasses on.

With 35mm SLR cameras, the simplest aid is a rubber eye cup to make you more comfortable using the camera with glasses; it will also protect lightweight plastic spectacle lenses from getting scratched.

If you prefer to remove your glasses you can buy *eye-piece correction lenses* from the camera-makers, though it is a problem to get correction lenses that really match your spectacle prescription. Some opticians will make up small lenses to fit the camera's eye-piece.

BATTERIES

These days batteries are as important to photography as film; most cameras need at least one battery to function, and more are needed for flash guns and winders. So you should buy and look after your batteries with as much care as you do your other photographic equipment.

Buy alkaline batteries as opposed to zinc carbon batteries. They have more power, last longer and are less likely to leak and ruin your equipment. Batteries should be replaced *at least once a year*, no matter how often you use your camera or flash. Replace all your batteries at the same time; it is not advisable to mix old and new stock. When batteries are discarded don't burn them. They can explode in heat. Buy batteries from shops with a high turnover: all batteries slowly lose power after manufacture.

Use batteries of the same type together, not mixing alkaline and zinc carbon. Check the + and − terminals carefully, so that you load the batteries correctly. Clean the terminals of new batteries and in your equipment before loading them. This can be done with the rubber on the end of a pencil or with a piece of rough cloth. Keep a list of the types of batteries you use so that you can replace the correct ones without having to take your equipment to the shop.

If you store your camera or other equipment that uses batteries for any length of time you should remove the batteries. Store them in a dry place at room temperature. If you store batteries loose where they are in contact with other metal objects they may short-circuit and lose power. If you have not used your flash for some time fire it a dozen times when you replace the batteries: this will help to re-activate the flash unit's power store.

If you are going on holiday take a complete spare set of batteries with you. The smaller ones can be very difficult to buy in some areas.

Polarity
Make sure that you put the batteries in your equipment with +/− the right way round. If in doubt check your instructions.

Cleaning
Gently clean the terminals of the batteries and your equipment each time you change batteries.

Nickel cadmium re-chargeable batteries

These are initially expensive, and you have to buy a charger as well, but if you use a lot of AA-size batteries they can be economical. They are not recommended for all equipment, so check in your instructions before buying a set. The charge will not last as long as alkaline batteries so you may need to buy two sets, since they take up to sixteen hours to charge. YOU MUST NOT ATTEMPT TO RE-CHARGE ANY OTHER TYPE OF BATTERY.

PRINTS

Tens of millions of colour prints are made each year. The most popular size is the $3\frac{1}{2}'' \times 5''$ En-print. The results you get are not always satisfactory and it is not necessarily your fault. Sometimes the processor is at fault. The low price of colour prints necessitates high-speed handling of your film, and with most of these examples you should be prepared to accept some variation in quality if you have paid a budget price.

Cropping

A metal mask is used to hold the negative firmly on a high-speed processor. To ensure that there are no black edges to a print from missing the picture area the mask is made slightly smaller than the negative: if your picture comes very close to the edge of the negative you will lose some of it under the mask. Try to leave a little space all round your subject to allow for this. If, on your negative, the subject is well placed and the cropping is excessive due to a mis-aligned mask, you should ask for it to be done again.

Flash

High-speed printers work in a similar way to automatic cameras: they try to produce an average print from a negative. If you have used flash outside or in a big room, there will be large dark areas of background: to compensate for these dark areas the printer will under-expose your subject. If your negative has detail in the faces, you should ask for the print to be done again.

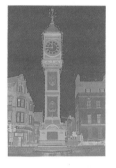

Space must be left round a picture for the printer's mask.

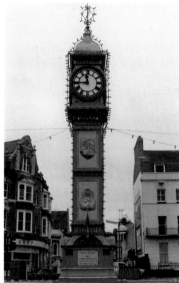

Flash faults like this are due to poor printing.

Dust

White spots on your En-print are caused by dirt on the negative: ask the processor to do the prints again. If the spots are on reprints it is possible that you have not stored the negative properly. Black spots on prints are caused by dirt in your camera.

Dust spots and drying marks are due to poor handling.

The blue cast is due to poor printing.

Colour cast

The printing machine tries to achieve an average with colour as well. To compensate for large areas of green in your picture it will add too much magenta. Excessive colour cast should be corrected by the processor.

If you have used colour filters in your pictures you should inform the processor when you take your film in, otherwise the machine will try to remove the colour.

If you have photographed something where an accurate colour-match is important you should let the processor have a colour reference. Accurate colour-matching is possible only with perfectly exposed prints.

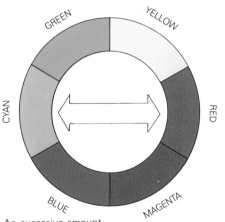

An excessive amount of one colour in your picture will often result in a colour cast of the opposite colour.

No film

If the processor loses your film you may be entitled to more than just its replacement. *If the pictures were important* you should contact your local Trading Standards Offices, Citizens Advice Bureau or a solicitor.

Where to go

Mail order printing is normally considerably cheaper than shop printing, but the accounting is tedious and, if you have cause for complaint, you may be involved in lengthy correspondence, so it is easier to deal face-to-face with someone in a shop. If your prints have been done by a shop you should look at them *before you leave* and make any comments then.

COMPOSITION

Most composition 'faults' can be cured simply by pausing before pressing the button and saying to yourself, 'Is that the picture I want to take?' Moving a few feet can change a very ordinary picture into one to be proud of.

If you have extra lenses or a middle-range zoom you will find that changing the lens will often rectify a weak composition. Careful use of a frame will emphasize the point of interest; filling the picture by going closer can cure an untidy background. If you take colour prints you can sometimes correct a weak picture by cropping it before putting it into the album; this is much harder with transparencies.

Avoid untidy backgrounds.

A natural frame will emphasize your subject.

Filling the picture

When you are photographing people, often a head and shoulders shot will reveal much more. This will normally mean moving closer, which has two effects: it will make your subject more prominent and it will cut down distracting backgrounds. A telephoto lens, which makes things seem bigger, will give more prominence to the subject without you having to move too close.

There will be times when you will want to show the background – perhaps a picture of friends *and* their house. Move the people closer to the camera and position them as a frame to the house. A wide-angle lens, with its greater depth of field, would be useful for this.

Using a frame

The secret of a good picture is to hold the viewer's concentration on the subject; this is easier if you can find a natural 'frame' to enclose the picture. When you look at a picture your eye scans it: a good composition directs the eye where the photographer wants it. For instance, in landscape you might use a tree to one side of your picture.

Distracting background

Unless it is particularly important to your picture, it helps to keep the background as simple as possible, or it will distract from your subject.

Look all round the viewfinder before you press the shutter. If the background is not satisfactory, change your viewpoint or move your subject.

No point of interest

Why are you taking the picture? Try to identify what your subject is, then arrange your picture around it. This does not mean making it the largest part so much as positioning the other elements to draw the viewer's attention where you want it.

Space

If your subjects are looking or moving in any particular direction, position them in the frame with more space in front of them than behind. The viewer's eye will then follow that direction. This trick can also draw attention to a point of interest.

Distracting colour

The eye is naturally drawn to bright colours. A tiny bright area in your picture will attract the viewer's eye away from your subject. People wearing coloured anoraks in the distance are a particular problem: wait for them to move away or change your viewpoint. In misty or foggy weather you can use spots of bright colour to emphasize your subject.

Composition is not a set of rules – what may be wrong for one picture will be right for the next. In the end it comes down to one thing: if you like what you see through the viewfinder press the button; if you don't – don't.

There is no point of interest. Think before you press the button.

You should allow moving subjects space to 'move into'.

FLASH

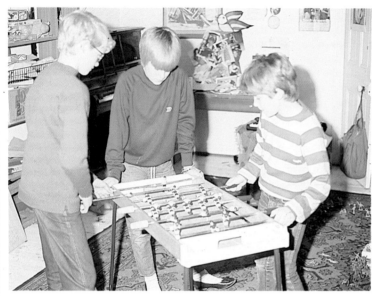

Over-exposed.

Correctly exposed.

Under-exposed.

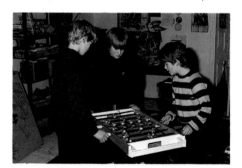

Fall-off.

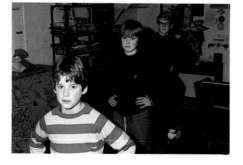

Over-exposure: the subject is too light
- Wrong aperture (too large) set on the camera.
- Wrong ASA (too low) set on the auto-flash.
- Auto-flash sensor did not pick up the subject: the light went between the people and the flash sensed a more distant subject.
- Too close with manual flash.
- Badly printed (*see* p. 18).

Under-exposure: the subject is too dark
- Wrong aperture (too small) set on the camera.
- Wrong ASA (too high) set on the auto-flash.
- Auto-flash sensor picked up object in front of the subject.
- Flash not fully re-charged: allow a few seconds after the 'ready' light comes on for the full charge to build up.
- Too far away with the manual flash.

Fall off: parts of the subject under-exposed, parts correctly exposed
The value of light from a flash 'falls off' dramatically as the distance to the subject increases. Whether you are using manual or automatic flash, anything in front of the main subject will be over-exposed, anything behind, under-exposed.
- Arrange your subjects parallel to the camera.

Black shadows: the subject has a heavy black shadow

The direct light from a flash gun is similar to the sunlight on a bright day, causing harsh shadows.

● Move the subject further away from the background.

● Move the flash gun away from the camera, using an extension lead. If you do not have a remote sensor to fit on the camera and monitor the flash, you must make sure the distance *from the flash to the subject* does not change.

● Bounce the flash off a white wall or ceiling: this will give a much softer light *and* lighter shadows.

An automatic flash will measure the correct light as long as the sensor is pointing at the subject. If your flash is not automatic you must estimate the distance the light will travel in order to calculate your settings. In a normal-sized room you could need an extra 2 stops of aperture if you use bounce as opposed to direct flash.

Wrong speed: part of the picture blank

The camera's shutter-speed was set too fast for flash. For perfectly exposed flash pictures, the camera's shutter must be fully open before the flash goes off and must not close before the flash is completed. The optimum speed for this is called the synchronization (sync) speed and is marked on the speed settings with an X, a different-coloured figure or some other identification: it will normally be 1/30, 1/60 or 1/125. This applies to all flash photography, including fill-in flash (p. 52), so cameras with faster sync speed are more versatile.

Flash reflection

If you stand square-on to a mirror or highly reflective surface the flash will reflect back into your picture.

● Position yourself at an angle of 45° or more to the shiny surface.

● Get spectacle-wearers to angle their faces slightly away from the camera.

Reflections
If you are taking flash pictures with a reflective background, angle yourself at about 45° to avoid flare.

Red eye: the eyes of your subject have a bright red glow

If your subject looks straight at the camera with the flash mounted close to the lens, the light will reflect into the camera from the back of the subject's eyes.

● Move the flash further from the lens.

● Turn on all the room lights to contract the iris.

● Use bounce flash.

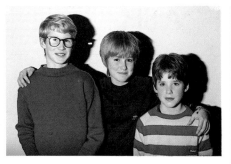

Direct flash will produce harsh shadows.

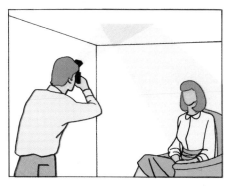

Bounce
Bounced flash will cure the above problem and red-eye as well.

Too fast a shutter speed will give this effect.

Glass or shiny surfaces will cause flare.

FOCUS

Part of a wrongly focused picture will normally be sharp; if all the picture is blurred it is probably caused by camera shake (*see* p. 13).

With simple cameras you must check the instructions to find your minimum focussing distance, then make sure you go no closer to the subject than the recommended distance. It will usually be around six feet; the Kodak disc can focus down to four feet.

If your camera has zone focusing, indicated by little drawings, these are not displayed in the viewfinder; remember to check the setting before you take each photograph. The split-screen focusing aid in the viewfinder of a 35mm SLR camera should give you accurate focusing every time. Try to find a hard edge to align the two images: if necessary you can turn the camera to utilize a horizontal line.

●	👤	🧍	👪	⛰
0.7m	1.0m	2.0m	4.0m	inf

With compact cameras make sure you choose the correct zone related to the size of your subject in the viewfinder. The last symbol is for views.

Depth of field
As well as being aware of the depth of field, with 35mm SLR cameras you can use it to make the picture as sharp as possible. The depth of field scale has two marks for each aperture and everything between them will be in focus at that aperture.

1 If you focus on the girl (10 feet) the monument will be out of focus at any aperture.

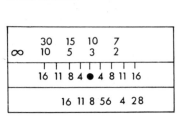

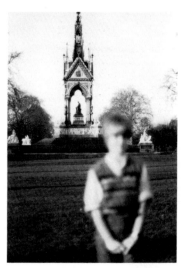

2 If you focus on the monument (inf) the girl will be out of focus at any aperture.

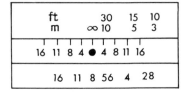

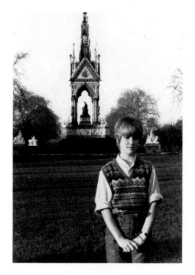

3 By looking at the depth of field scale you see that between the two f16 marks you can fit in both 10 feet and infinity.

HOW TO CHOOSE EQUIPMENT

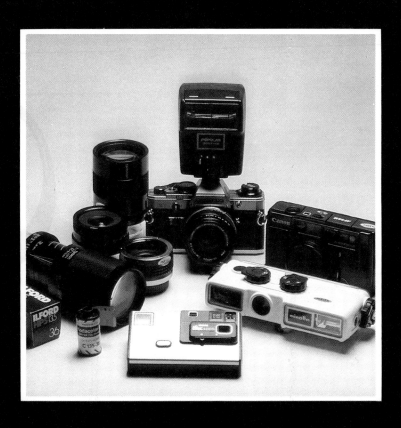

CAMERAS

There is such a range of cameras in the shops that choosing the right type of camera for your requirements, let alone the right make, has become very difficult. Most cameras available these days will measure the brightness of your intended picture and, used properly, should give you a correctly exposed photograph. To take pictures in bad light all cameras will have either a small built-in flash or the facility to connect up with a separate flash unit. But with these two broad areas any similarity between the five main camera-types available ends. You can choose from the *110 cartridge camera*; the *disc camera*; the *instant picture camera*; the *35mm compact* and the *35mm SLR*, each with differing price range, ease of use and quality of results.

110 cartridge cameras
In the main these are the cheapest range on the market. They are very easy to load and use but their design often makes accurate framing and steady holding difficult. Some expensive models are available with high quality lenses and controls, but using the same film cartridge. The small size of negative is unsatisfactory for big enlargements.

Disc cameras
Although these are the simplest cameras to use, their sophisticated design has virtually eliminated the main causes of unsatisfactory pictures. The very small size of negative makes it unsuitable for big enlargements.

Instant picture cameras
The advantage of these cameras is that you have your picture immediately. This is not only more fun, but also allows you to re-take any unsatisfactory pictures then and there. However, it is difficult to get reprints and enlargements, and the film packs are expensive.

35mm compact cameras
This type of camera is now the popular choice for good snapshots. The more expensive types offer fully automatic operation, including focusing, winding and re-winding. The larger size of negative gives good prints and enlargements.

35mm SLR (single lens reflex) cameras
Because of their versatility, sophisticated controls and interchangeable lenses, these are the main choice for the enthusiast. Equally such features make them rather complex for snapshots.

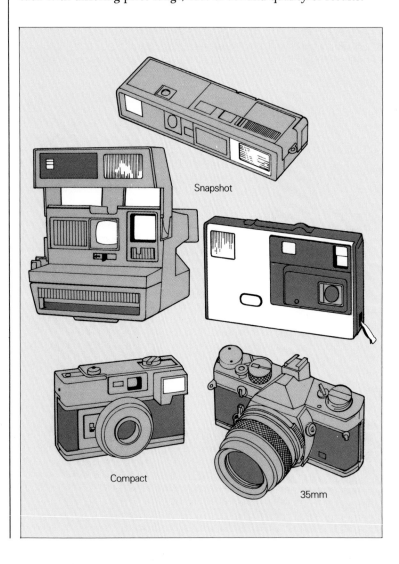

Snapshot

Compact

35mm

Snapshot

When you go to buy a simple camera for taking family snapshots you will normally have two main criteria: is it easy to use and how much does it cost? There are other features to look for, though, that will help give you much better results.

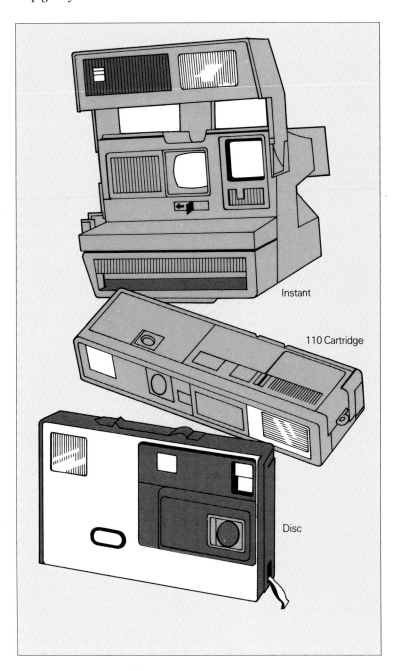

Instant

110 Cartridge

Disc

Holding
Many simple cameras use relatively slow shutter speeds to take the picture. Unless the camera is held steadily this can lead to blurred pictures. See how comfortably you can hold the camera. You must make sure that it is not too easy accidentally to put your fingers over the lens or flash. Some simple cameras have a folding grip to help.

Shutter release button
Make sure you don't have to push the release button too far or too hard. A button that works smoothly will greatly assist in keeping the camera steady.

Film range
Only one type of film will fit disc cameras; the same applies with the three makes of instant picture cameras. But two different 'speed' films fit 110 cameras: 100 ASA for normal use and 400 ASA film for dull weather; the 400 film also increases the flash range. Most cameras make the adjustments automatically when you load the film, but some of the cheapest 110 cameras cannot and simply filter out its advantages. Check that both film speeds can be fully utilized.

Extra lenses
Many snapshot cameras have extra lenses built in to slide across the main lens. A *close-up* will enable you to fill your viewfinder with a spray of flowers without the picture going out of focus. A *telephoto* will make distant things seem closer. You will find them both easier to use if your viewfinder image also changes when you are using them.

Viewfinder
Because the viewfinder and lens of all these cameras are separated, you will need to compensate when photographing objects closer than two metres or you will cut off part of your subject. This problem can be particularly bad with 110 cameras; you will find it easier if the viewfinder has a bright frame indicating picture area and compensation marks. This bright frame will also assist your framing if you wear spectacles.

Compact

Compact cameras are rapidly becoming the most popular type for the family, designed to be simple to use and to have a minimum of controls. At the top end of the range a compact camera will be so automatic that it will focus, expose and wind on automatically. The larger size 35mm negative gives better quality prints and there is a larger range of film available in most shops.

Camera designs vary and you must make sure your choice has the features you need.

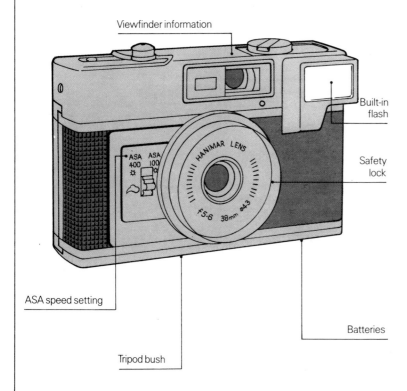

Viewfinder information

Built-in flash

Safety lock

Batteries

ASA speed setting

Tripod bush

Viewfinder information

Most compact cameras have to be focused, usually in zones for head and shoulders, full length and landscape pictures. You will avoid focusing errors if the settings are displayed in the viewfinder. A bright frame within the viewfinder, indicating picture area, will help you to frame your picture accurately, especially if you wear spectacles.

Self-timer

This will delay taking the picture for up to fifteen seconds from the shutter being pressed. If the camera is properly supported and the picture framed, it will allow the photographer to include himself in the picture. It is particularly useful for family groups.

Safety lock

Pictures are often blank because the lens protection cap has been left on. A switch which locks the shutter unless the cap has been removed will avoid this problem.

Tripod bush

This will allow you to fit the camera to a mini-tripod for pictures needing long exposures, or when using the self-timer.

Batteries

Make sure that the camera uses commonly available batteries, such as the AA size; unusual sizes may be difficult to obtain.

ASA speed setting

This programmes the camera to the speed of film you are using. The most common speeds are 100 ASA and 400 ASA, but some colour slide films have different speeds. Make sure the camera can be set for the films you will be using.

Built-in flash

Most compacts have built-in flash; if not, add the price of a small flash to the camera price. A small accessory flash may have a longer range than a built-in unit.

Auto-focusing

Most auto-focus compact cameras use either infra-red or contrast comparison to focus: there is usually a small sight in the viewfinder which indicates the focusing point. Whilst infra-red will give problems if photographing through glass, it is generally more versatile than contrast comparison. A camera which locks the focus with a half-pressure on the shutter-release will allow you to use more pleasing framing.

Auto-winding and re-winding

This will wind on the camera after each picture so that you are ready for the next one and at the end of the film it will re-wind the film into the cassette. This facility can exhaust batteries quite quickly. Make sure there is a *film travel indicator*, as you have no re-wind handle to check that the film has been loaded correctly.

35mm

The 35mm SLR camera is the most popular type for the enthusiast photographer. It can be modified by changing the lens to a wide-angle to get more in the picture; a telephoto to make things appear closer; or a zoom lens that allowed you to choose a picture-size within its range. It is also capable of utilizing a large choice of accessories to assist with close-up, action and scientific photography. With a wide range of 35mm cameras available you must try to select one that has the features you need for your present and future requirements; whatever your requirements there will be several 35mm cameras that meet them. Since the controls and the general feel on cameras differ, you should ask to see and handle several before making your choice.

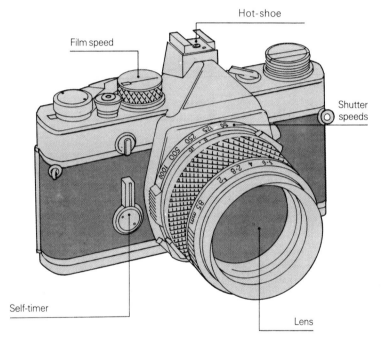

Hot-shoe

Film speed

Shutter speeds

Self-timer

Lens

Automatic exposure

There are three types of automatic cameras. With *shutter priority* you set the speed and the camera sets the aperture; this is useful for action photography. *Aperture priority* cameras allow you to set the aperture and the camera sets the speed; this type is more useful for general photography, but you must be careful not to take hand-held pictures at slow speed. *Programme* cameras set both aperture and speed to give you the best average settings for the light.

With all cameras it is advisable to also have a *manual* control: then you can easily over-ride the automatic settings in difficult light conditions when you become more confident. Some cameras incorporate two or more of these facilities and are called *multi-mode* cameras.

Flash connection

Most cameras use a hot-shoe flash connection which is more reliable than a flash connection socket. However, a hot-shoe can restrict you to keeping your flash mounted on the camera, so a camera with both will be more versatile.

Lens

Most cameras are sold with a 50mm standard lens. For general photography you would find a standard zoom lens (28–80mm) a better alternative.

Self-timer

By delaying an exposure for up to fifteen seconds from pressing the shutter release, the photographer may include himself in the picture.

Film speed

With the introduction of 1000 ASA film for dull weather photography, the ASA speed dial should have a range of at least 25 ASA–1600 ASA.

Shutter speeds

Maximum speeds of more than 1/500th are seldom needed except for very fast action pictures. The camera will need to be set at a particular speed to take flash pictures. The faster this is, the more useful it will be when flash is used for fill-in in daylight (*see* p. 52).

Exposure over-ride

Since automatic cameras strive to produce an 'average' picture, an easy-to-use compensation dial is vital for unusual light conditions. An alternative is a 'backlight button' which increases the exposure when the background is brighter than the subject.

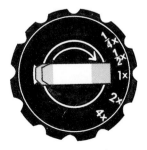

Exposure compensation
Set a larger multiplier for a brighter background and a smaller for a darker background.

LENSES

One of the main advantages of the 35mm SLR camera is that you can replace the lens on the camera with other lenses of different properties. It is the only popular camera with this facility: all the compact, instant and snapshot cameras have a fixed lens, although you can often buy supplementary lenses to fit over the existing lens for close-up photography.

When you buy an SLR camera it will normally be fitted with a 50mm lens. This is called a standard lens and 50mm is the *focal length*: the area of a subject it sees is approximately the same area that your eyes see properly. If you uncouple the standard lens and replace it with an alternative, you can open up a new world of photography.

There are over fifty types of alternative lenses to fit most SLR cameras from 'fish-eyes' that can see 180°, to giant telescopic lenses that will enlarge a subject twenty-four times. In between are lenses for close-up pictures, auto-focusing lenses, lenses for night photography, in fact lenses for almost any application.

Although many of these alternative lenses are very expensive and are only intended for the professional photographer, a large range are very reasonably priced and are well within the budget of the family photographer. These broadly come into three categories: *wide-angle*; *telephoto*; and *zoom*.

Wide-angle lenses are useful for photographing groups in restricted spaces.

A short telephoto lens is ideal for portraits, giving pleasing proportions to the face and putting distracting backgrounds out of focus.

Although a zoom lens will be more expensive than most others it is the most popular. Its focal length is variable and has a range of applications. The most versatile is the 80–200mm lens, which was used for this telephoto shot.

Wide-angle lenses

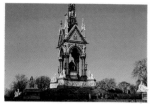
Standard lens.

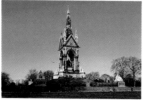
35mm lens.

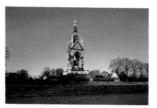
28mm lens.

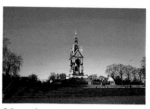
24mm lens.

Standard lens: this is the coverage of a 50mm lens.

35mm lens: this lens gives a modest increase in picture area and very little distortion. It is probably too close to the 50mm to be an effective second lens.

28mm lens: this is the most popular wide-angle lens and because of mass production it is very reasonably priced. The perspective will increase pleasingly and the distortion is minimal.

24mm lens: the increase in distortion and perspective makes this lens less popular than the others except where that effect is required. It will be more expensive than the 28mm.

Problems with wide-angle lenses

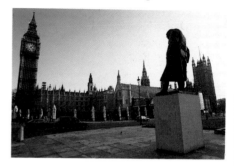

Verticals: what was acceptable with a road may be unacceptable with a building, but this effect can be very dramatic with skyscrapers.

Broadly, a wide-angle lens from the same position will cover a larger area of a subject than a standard lens will. To do this a wide-angle lens has a shorter focal length than the 50mm; the popular range consists of the 24mm, 28mm and 35mm. Because a wide-angle lens gets more in, they are particularly useful for photographing *landscapes*, *parties* and *groups of people*, or if the photographer is physically restricted in space, say by the size of a room.

A wide-angle lens changes the perspective of what you see and apparently increases the distance between objects: a photograph taken down a road with a wide-angle lens will make it seem far longer than it is. Because of this you must be careful when you pose people; a leg stretched towards the camera will look unnaturally long when seen through a wide-angle lens.

An advantage of these lenses is that they have a much greater depth of field than a standard lens. A 28mm set at f8 can have everything between 5 feet and infinity in focus. This makes them invaluable when you want a completely sharp picture. This is an advantage at parties where it is too dark to focus properly. By setting your camera and flash at f8 and focusing at 6 feet everything from 4–15 feet will be sharp with a 28mm lens: you will not need to focus at all. Make sure that your flash will cover the extended area of a wide-angle shot, or you will get dark edges to your picture.

Faces: be very careful when using a wide-angle lens to photograph people: by increasing the perspective the whole proportion of the face appears wrong.

Telephoto lenses

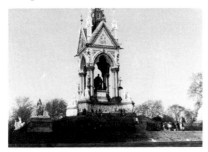

Standard lens
This is the coverage of a standard lens.

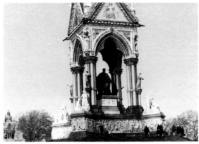

85mm lens
One of the three 'portrait' lenses, the magnification is too small to make it a useful second lens.

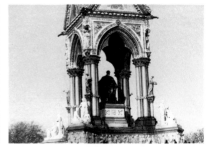

100mm lens
With a picture-area a quarter of the 50mm's, this portrait lens is a versatile choice for the photographer who does not need huge magnification.

135mm lens
By far the most popular and reasonably priced telephoto lens for all applications, it is especially suitable for 'candid' pictures of children.

200mm lens
A true telephoto lens that covers 1/16th of the picture-area from a 50mm lens. Its magnification and limited depth of field make this an enthusiast's lens.

500mm mirror lens
The use of mirrors in the design of this lens makes it far smaller and lighter than a normal 500mm. It is also considerably cheaper, but the design means that you cannot alter the aperture and have to depend on your shutter speeds for control. It is a low-cost compromise for the photographer who needs great magnification. Out-of-focus highlights have a distinctive doughnut shape.

A telephoto lens is the opposite of a wide angle; working like a telescope, it magnifies a small area of the subject covered by the 50mm. They have longer focal lengths and the popular sizes are 85mm, 100mm, 135mm, 200mm and 500mm. The 85–135mm range have a relatively small magnification and are popular for *portrait* photography. The longer lenses, with their greater magnification, are invaluable in situations when you may not be able to get close to your subject, such as *nature* and *sports* photography.

A telephoto lens will compress the perspective and make things seem closer to each other, so that a telephoto picture of a crowd will make the people seem jammed together. The shorter telephoto lens is very popular for portrait photography: by seeming to reduce the distance between the nose and the ears it imparts very pleasing proportions to a face.

The depth of field with a telephoto is greatly reduced, so it can be used to lose unsuitable backgrounds, but this does mean that focusing must be very accurate.

Problems using telephoto lenses

Apart from being harder to hold steady, all telephoto lenses accentuate any camera movement. To successfully hand-hold them you need to have your camera's shutter-speed set similarly to the focal length. With a 135mm lens you should not hand-hold at less than 1/125th; it is virtually impossible to hand-hold a 500mm lens.

Because of the optical design the longer telephoto lenses will not work with the split-screen focusing aid in the viewfinder: half of it will go black. You can change the focusing screens on some 35mm SLRs and a clear screen would be better, but changing screens is fiddly and it will be better to learn to cope with your existing one.

Zoom lenses and convertors

Although a zoom lens will be more expensive than most lenses in the other two groups, it is the most popular with the family photographer because it is the most versatile: it combines several other lenses. A zoom is designated by its minimum and maximum focal length, so a 28–85 zoom incorporates the coverage, depth of field and perspective properties of a 28, 35, 50 and 80mm lens and, because of its variable controls, any other setting between its minimum and maximum.

So, though a zoom lens will be both heavier and more expensive than any individual lens, you should compare the total cost and weight of all the lenses it replaces. The only real drawback with a zoom is that its maximum aperture will be smaller than its fixed counterparts; it is not your best choice for pictures in bad light.

There are two methods of zooming. The *two-touch* has separate controls for focusing and zooming; the *one-touch*, where the controls are combined and you twist to focus and pull back to zoom, is the easier to use and the most popular.

Tele-convertors or extenders

These fit between the lens and the camera to increase the focal length of a lens: a 2× convertor will change a 100mm lens to a 200mm.

There are problems with their use, but they are a very economical way of extending your lens range as long as you are aware of their limitations. It is better to buy a convertor that is matched to the lens you are using it with, otherwise you may suffer considerable loss of picture quality. They reduce the working aperture of your lens, in the case of a 2× by 2 stops, and whilst a camera's TTL metering system will allow for this, you will have to compensate if you are using flash.

Zoom lenses and convertors

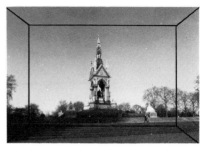

24–35mm wide-angle zoom
Could replace the 24mm, 28mm and 35mm lenses. Ideal for landscapes and groups, but has many more creative possibilities. Extra care is needed in focusing a wide-angle zoom.

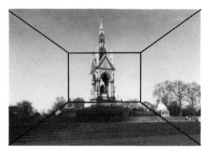

28–85mm mid-range zoom
With a range from wide-angle to short telephoto, this lens would make the ideal substitute for a standard lens on a camera: its bulkiness is more than compensated for by its versatility for all family pictures.

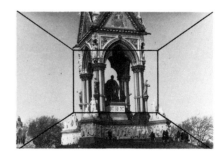

80–200mm telephoto zoom
The most popular choice as a second lens for the active photographer, excellent for portraits and outside action. Be careful with your speeds because the hand-holding problem with telephotos applies to zooms too.

FILM

When you buy film there is always a large range of types and speeds available. Why should you buy one type instead of another?

Film is firstly classified by end products, so choose the type of film depending what your end use will be. *Colour transparency film* produces positive colour slides for projecting and viewing. You can get prints from slides but they can be expensive; some films include processing, some do not. *Colour negative film* produces negatives for colour prints or enlargements. *Black and white negative film* will give you black and white prints but it is not so easy to get processed. On the other hand it is easier to process yourself than the other types.

All films have a 'speed', which is the measure of its sensitivity to light. This speed is expressed as an ASA, Din or ISO number: the higher the number the faster, or more sensitive, the film. In Europe you will come across Din and ISO; in England and America it is usually ASA. The speed of the film you choose will depend on your intended results and the light in which you intend to take pictures.

Slow speed film (25–50 ASA) is normally used for high quality results in very good light, but often requires slow shutter speeds and/or large apertures. You will often have to support your camera using a tripod for a sharp result. The fine grain makes it particularly suitable for landscape, nature and close-up.

Medium speed film (64–200 ASA) is the most versatile for general subjects. Reasonable light will allow you to hand-hold most cameras; it is less suitable for fast-moving subjects and dim light. Use for subjects like travel and family.

Fast film (400 ASA) gives an increase in grain size, but the compensation is that you can use it for fast-moving events and in dull conditions.

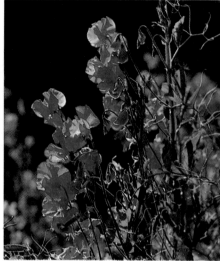

Slow film
Heather Angel used fine-grained slow film for this picture of sweet peas.

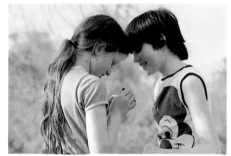

Medium film
Medium-speed film has the right blend of speed and grain for this candid picture of two little girls playing.

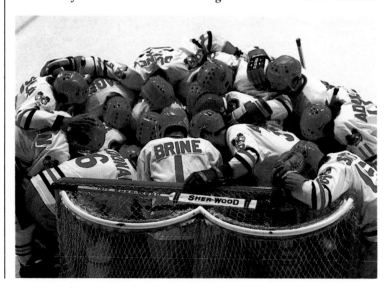

Fast film
Eamonn McCabe needed fast film to compensate for the lighting at an ice hockey match.

It is two exposure stops faster than 100 ASA film, which can be the difference between getting a picture or not in bad light.

Certain films do not fall within the normally accepted categories of slow, medium and fast: some have very broad uses, some more specific applications. They should all be available in specialist shops.

Polachrome 35mm Autoprocess (40 ASA) is slightly grainier than comparable conventional films. It is an instant transparency film, sold in cassettes of 12 or 36 exposures complete with processing pack, and will give mounted colour transparencies in three minutes without a darkroom, washing or a controlled temperature. Instead it is placed in a small autoprocessor with its processing pack, and wound through.

Polaplan CT 35mm Autoprocess (125 ASA) is similar in process to the above but gives fine-grain black and white transparencies. It is only available in 36-exposure cassettes.

Ilford XP1/Agfa Vario XL uses the principles of colour film to give very fine-grain black and white negatives. Because of the design of the film the ASA speed is variable, and the films will produce excellent results within the range of 100 ASA to 1600 ASA on the same roll, enabling you to use the same roll for subjects as diverse as a sunny scene and a dark interior. Specialist processing is recommended.

3M 640T (640 ASA) is a transparency film designed for use with artificial light (not flash). It is particularly suitable for indoor sports and theatrical events that are lit with spot- or floodlights.

Kodacolor VR1000 (1000 ASA) is designed to use in very poor light or when very fast speeds are needed and is only available in colour negative form. It is over twice as fast as 400 ASA film, and is versatile enough to use under most light sources without getting false colours, so it is ideal for use in bad winter weather or inside without flash.

Polachrome autoprocess
This Polachrome slide was ready to view in three minutes.

Ilford XP1
The structure of XP1 makes it ideal for most picture opportunities.

3M 640T
Because 640T is designed for use with tungsten light there is no colour cast in this picture of 'Son et Lumière' in Egypt.

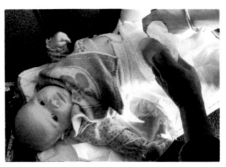

Kodacolor VR1000
VR1000 allows pictures to be taken in poor light.

FLASH UNITS

With flash guns you usually get what you pay for in both power and versatility, so buy the most powerful flash you can afford. The power of a flash gun is expressed as a *guide number* (GN), measured in feet or metres related to a film speed. If you multiply the distance from the flash to the subject by the aperture you would need, the answer is the guide number. A flash unit with a GN 80 ft/100 ASA would need an aperture of f8 at 10 feet from the subject or f4 at 20 feet using 100 ASA film (8×10 or $4 \times 20 = 80$). When comparing flash units, make sure the guide numbers are expressed similarly.

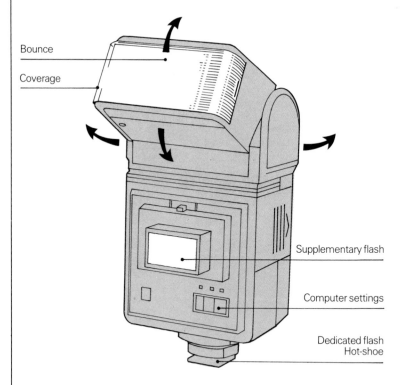

Bounce

Coverage

Supplementary flash

Computer settings

Dedicated flash
Hot-shoe

Computer settings
Most flash guns now have small computers that control the light output. The more settings you have the more versatile the flash will be, especially for fill-in flash in daylight.

Bounce
You will get nicer light and less harsh shadows if you can bounce the flash off a white ceiling or wall. Flash units where the flash head can be moved whilst the computer sensor still points at the subject are best. Remember that because the light has to travel a greater distance, you will need more power for bouncing.

Supplementary flash
When flash is bounced off a ceiling it can cause unusual shadows under chins. Some units have a small secondary flash to eliminate this in portrait-style pictures.

Dedicated flash
Certain units are designed to work in conjunction with particular cameras, and to transmit flash data through the camera's viewfinder. The most sophisticated units adjust the flash output automatically for the aperture set on the camera, set the shutter speed when the flash is switched on and measure the flash exposure using the camera's exposure meter.

Coverage
If you use a wide-angle lens make sure the flash will cover the same area as your lens, or you will get dark edges to your pictures. Some units have clip-on diffusers for wide-angle use.

Hot-shoe
Whilst a hot-shoe is the most efficient way of connecting the flash to the camera, having the flash immediately above the lens is not always desirable. A flash with a lead as well as a hot-shoe allows you to move the flash; more expensive units have separate sensors to fit on the camera when the main unit is away from it.

FILTERS

There are a large number of filters on the market for making colour correction and special effects, but they are only really suitable for use with 35mm SLR and compact cameras. There are only two filters that most camera-owners using colour film might need:

● An *ultra-violet/haze/skylight* filter will cut out some of the excessive blueness that affects pictures taken on hazy days or at high altitude. An added advantage is that this low-cost filter will protect your expensive lens; many photographers leave them on their lenses all the time.

● A *polarizing* filter will increase the depth of colour in most subjects, cut down reflections on glass and water and, more importantly, will preserve the blue of sunny skies, especially when used at 90° to the light. It is relatively expensive but, for holiday and landscape pictures, will give you results that make it a worthwhile investment. Because of its darkness, exposures will have to be increased; cameras with 'through the lens' (TTL) metering, which includes most 35mm SLRs, will do this automatically.

Both these filters are available in either glass or plastic to fit all 35mm SLR and many compact cameras. For maximum protection it is better to buy a glass ultra-violet filter, but glass filters are made in a large range of sizes so take your camera with you when you go to buy one. If you have more than one lens, fit a filter to each.

There are several ranges of plastic filter systems on the market that offer a wide range of filters for creative effects as well as the two mentioned above. Because they are easily adaptable to different lens diameters they are a good buy if you want to experiment with other filters. These are made of optical plastic and are considerably cheaper than their glass equivalents.

In black and white photography an *orange* filter will restore the balance between sky and cloud in black and white photography; it will also need compensation.

Orange filter
An orange filter will darken blue skies in black and white pictures.

BUYING A KIT

Depending on the subjects you want to photograph you will find that some extra equipment will assist in getting good pictures. Your own experience will eventually dictate your selection, but some basic ideas are set out below. Photographic shops are full of gadgets and the temptation is to feel that all these will help you take better pictures. Resist this and keep your equipment as simple as possible.

Whatever pictures you take, your camera is a precision instrument and must be looked after, so a suitable case and a cleaning kit are a must for every camera owner. A dirty lens will cause flare and degrade the quality of your pictures. Each time you load a film you should check that your camera is clean, inside and out, but be careful cleaning the shutter blind when the back is open.

Family shots

A mid-range zoom as an alternative to the standard lens would cover all your requirements from holiday pictures to portraits. A good flash-gun with a tilting head for bouncing will give you a much softer light in your flash pictures. For the times you need extra stability, a mini-tripod would be sufficient. If you are photographing young children, a winder will help you concentrate on them; use medium speed film except for outdoor shots in winter, when a fast film would be better.

Landscape shots

A 35mm or 28mm wide-angle lens gives better coverage of views. A polarizing filter will cut out reflections and give you better colour. Use slow and medium film to give higher quality pictures and enlargements. A sturdy tripod will be a necessity, because the mix of slow film, polarizing filter and great depth of field means using slow shutter speeds.

Action shots

Most sporting events are too far from your camera for a 50mm lens: a telephoto of 200 or 300mm will give suitable magnification. Flash is either unsuitable or prohibited, so use fast film and shutter speeds to stop the action.

Nature shots

To achieve high quality results you should use slow and medium-speed film. For wildlife a telephoto lens will allow you to get pictures without disturbing your subject. A 2× teleconvertor will double your lens range; a macro lens or some other close-up aid will be needed for small subjects. You will also need a tripod for steadiness with most shots.

TECHNIQUES

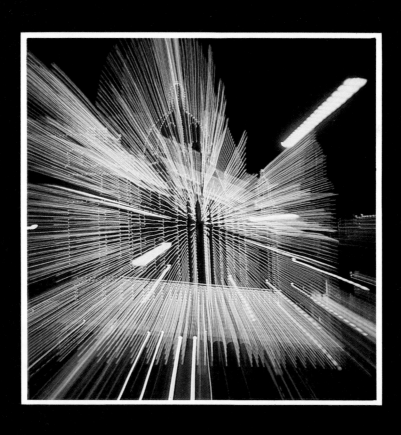

SPECIAL EFFECTS

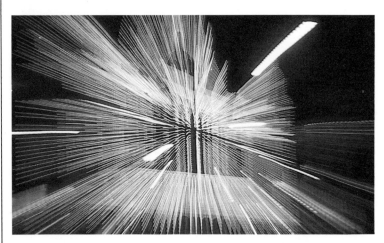

Zooming
The camera was mounted on a tripod and an 80–200 zoom lens was used to make this unusual study of Harrods at night. Zoom technique does rely on smoothness (*under*).

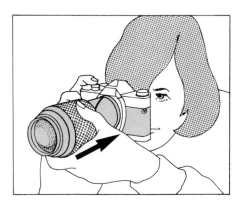

When taking photographs you need not accept the picture as you first see it in the viewfinder. To achieve more interest there are a whole range of effects that you can add at the time of taking the pictures, or else do at home when you have got your prints back. The next few pages will give you an idea of the different types of creative special effects you can achieve and it will be worthwhile experimenting until you are happy with your results.

Movement

Although in most photography you strive to get your pictures as sharp as possible, there are several effects where it helps to allow the subject or even the camera to move during an exposure.

Zooming: mount your camera firmly on a tripod and fit a zoom lens. With the zoom control at the shortest focal length which gives the smallest image, frame up on an interesting and well lit subject. Set the camera to 1/4 sec and make your exposure as you zoom the lens back. Because the image is enlarging as the exposure is made, you get an 'exploding' effect, particularly beautiful with lights at night.

Light trails: at night, set up your camera on a tripod where you have a good view down on a busy road junction. Make sure you can see the headlights and tail-lights of the passing traffic. You will find bridges over motorways give you a good vantage point although the traffic moves in straight lines. Set the aperture for f11 (100 ASA) and the shutter at 'B'. Using a cable release, open the shutter and lock it open *with the lens cap on the camera*. Every time there is a burst of traffic take the lens cap off the camera! Do this 4–5 times to allow the lights to build up on your film. Then close the shutter.

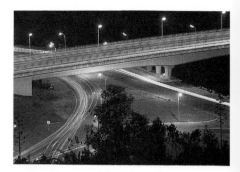

Light trails
A location with more than one line of traffic will give the best light trails.

Panning: to emphasize a moving subject it is better to blur the background. With your camera shutter set at 1/15, follow the subject in

your viewfinder by swinging your body, making your exposure about halfway through your swing. Practise to achieve a smooth flowing motion: your movement will compensate for the subjects. If you use too fast a shutter speed you will also freeze the background and thus lose the effect.

Long exposures: many activities that involve smooth movements can be better shown with a long exposure, such as a gymnastic display. To show the grace of the athlete you should mount your camera on a tripod and set the shutter to give you an exposure between 1 second and 1/30th. Pick a moment when there is a lot of movement and make your exposure. On a sunny day you might have difficulty achieving a long enough exposure, but your polarizing filter will cut down the amount of light without affecting the colours. At night a similar effect can be achieved at fairgrounds with lots of moving lights.

Long exposure + flash: although flash will not be effective if used with speeds faster than the recommended sync speed, it will work at slower speeds. Set your camera at $\frac{1}{4}-\frac{1}{2}$ sec and take an exposure read-

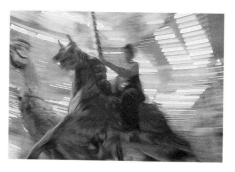

Movement
Both panning and a long exposure were used to capture the excitement of a roundabout. The panning has kept some detail in the child and horse while emphasizing the speed.

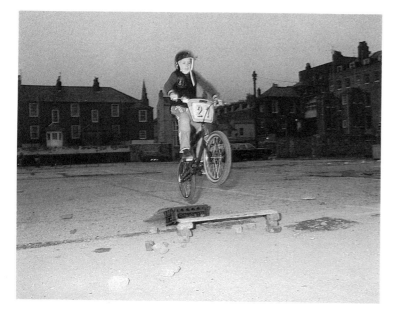

Long exposure and flash
By using flash in this dusk picture of a young rider on his BMX bike, the essential detail is preserved with a slight blurr to counteract the 'freezing' effect of the flash.

ing for the surrounding light: set your flash for this aperture but set the camera one stop smaller. Now make your exposure. Either move your camera slightly or get your subject to move while the shutter is open: because the light from a flash gun is very fast it will freeze the main subject but you will get movement in the background. You will have to experiment with different speeds to find what suits you.

Reciprocity failure: when certain films are given exposures of more than 1 second their colour may alter slightly and they appear to become less sensitive to light. The maker's instructions will give advice on counteracting this.

Filter

There are many effect filters on the market. The plastic system filters have the largest range, are reasonably priced and the most versatile, but think carefully before buying effect-filters: as with all special effects they can become boring if over-done.

Soft focus: there are many ways of achieving a diffused effect. You can buy diffusing filters of many kinds but a little vaseline smeared on a plain glass filter, leaving the centre clear, or a piece of black nylon stocking stretched over the end of the lens, will be as good as any. You can buy coloured vaseline in some filter kits for a coloured soft focus effect.

Some filters will give you a fog effect with landscape because the amount of diffusion is graded down the filter; these filters are only available in the square system range.

Diffusers are particularly suitable for portrait and glamour photography because they conceal the texture of the skin as well as any small blemishes.

System filters
System filters are the most economical way of buying filters. If you change your camera you only need to replace the connecting ring. They can be fitted on top of an ultra-violet-type filter.

Soft focus
A soft focus filter has accentuated the fairy tale quality of the beadle at the Lord Mayor's Show.

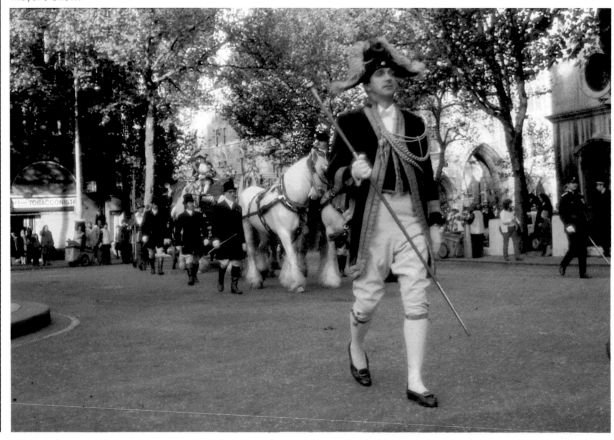

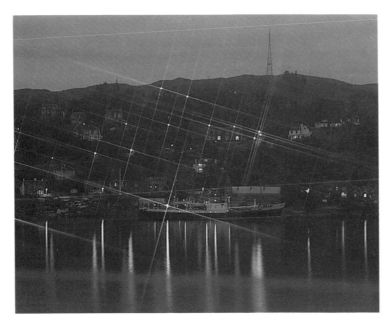

Star lights
A 4-point star filter
has given a dream-
like quality to this
twilight picture of a
small harbour.

Multi-image filters
A speed filter was
used to give this
effect.

Star lights: one of the most popular effects is to give any bright lights in your picture a star effect, something often seen in television variety and pop shows. The filter range includes 2, 4, 8 and 16 point stars. You will get the best effect with larger apertures and you should rotate the filter to put the stars where you want them. They will only work if there is a strong bright light in your picture, such as the lights on a Christmas tree.

Multi-image filters: these will repeat your main image in either circular form, making up an interesting pattern, or a straight line, giving an impression of speed. The results from these type of filters can be fun, but don't use them too often or they will become boring.

Graduated filter
A grey graduated
filter was used to add
a dramatic sky in this
picture of an unusual
modern office
building.

Graduated filters: by grading the colour down the filter, these allow you subtly to change the colour of half your picture, particularly useful with skies. Because the sky is normally considerably brighter than the ground, most cameras over-expose and make the sky too light. A grey graduated filter simply cuts down some of the light from the sky; a blue will enhance the blueness. You can also get a range of unusual colours, such as reds and greens, that will give you weird sky effects and for the best effect you should take your exposure reading before fitting the filter. The big disadvantage to these filters is that if anything cuts the horizon, it will also have its colour changed.

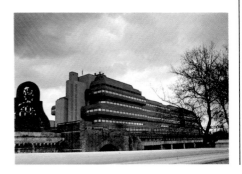

Montage

By cutting out parts of one photograph and pasting them on to another you can create your own surreal pictures. You will often have to take some pictures especially for montaging – black and white are easier – so you will get a better effect if you plan your ideas beforehand. You must work very carefully and deliberately to get good results but the only equipment you will need is a supply of pictures to cut up, some rubber-based glue and a sharp pointed knife (a modelling knife or scalpel will give you more accurate results).

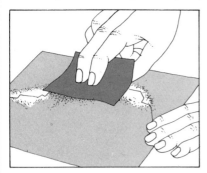

Hold the first picture up to the light and mark the rough outline you are going to cut out on its back. Using 'flour' grade sandpaper, gently sand the outline to reduce the thickness for pasting, being careful not to go through the paper.

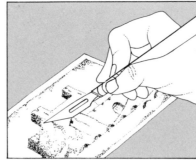

Turn the picture over and slowly cut out your subject; you will find it easier if it has a clearly defined edge; cut as closely to this as possible.

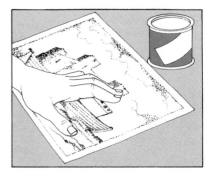

Paste the cut-out on to another photograph with the glue. If you have to move the picture around to get the right effect you will find that rubber-based glues will remove easily without marking after they dry. A better appearance can be obtained by re-photographing your montage when it is finished.

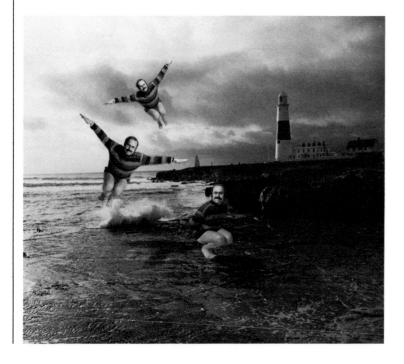

Montage
Three negatives were used to create this surreal picture. The 'birds' were taken specially and printed at a size to suit the seascape.

Multi-exposure

Although a 'double exposure' is a fault when done by mistake, the effect can be used to produce very different pictures. Some cameras have a facility for double-exposing a picture, disconnecting the film wind-on so that you can re-cock the shutter without moving the film. There are several other ways of making a double exposure. Take up any slack in the film cassette by turning the re-wind handle until you meet resistance, then take the picture. Depress the re-wind button, usually on the base of the camera. When you wind on simply re-cock the camera without moving the film. This may not place the second exposure exactly over the first. Take an extra shot *with the lens cap on* to avoid accidental overlap and to re-engage the wind-on mechanism.

Another method is to re-expose the whole film: when you load the film mark it to line up with a similar mark in the camera-back. After the first exposures carefully re-wind the film so you don't loose the tongue: if you stop re-winding when the pressure comes off the handle you keep the tongue out of the cassette. Then re-load the film, using the marks to register for the second exposures. If you use a processor, do not have the slides mounted after using this technique: the cutting machine is pre-set and may cut into the pictures. You can also achieve selective re-exposure. Masks that fit into filter systems allow you to expose first one half of the picture, then the other.

With the camera on a tripod the background will not move. Expose half the picture, then slide the mask across to expose the other, first moving your model across. Similarly a filter that exposes an inner circle first, then the outer area of a negative, is available.

With complete re-exposure allow half normal exposure for each shot, or else the total picture will be over-exposed. With 'half and half' filters measure the exposure before fitting the filter.

A double exposure of the same object with different lenses and different colour filters is a reasonably simple beginning.

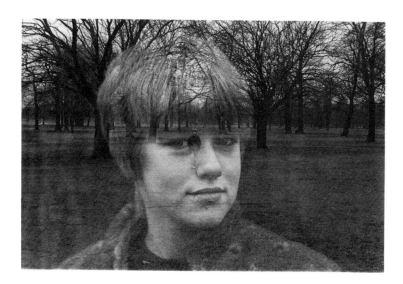

Multi-exposure
Two exposures with different lenses were used to create this unusual portrait. A wide-angle lens gave the general view for the first exposure; the camera was then re-cocked and a short telephoto lens was fitted. The girl was then positioned against a dark tree to reduce too much overlap on the background.

Colour effects

Toning: certain chemicals that are readily available at photographic dealers will change the overall colour of a black and white print by means of chemical reaction; the process is irreversible. Since the process uses a finished print you do not need a darkroom – simply a table, two dishes big enough to fit the print, a water dish for washing and a pair of rubber gloves. Sepia toning is the most popular and consists of two chemicals, a bleach and a toner*. The toner may give off a rather unpleasant smell but you can buy an odourless kit.

Make sure the print has been properly washed. Since the density of the print will affect the final tone it is a good idea to experiment with several different prints.

Coloured light source: the easiest way to change the colours of a picture is to colour the light source. This is not easy in sunlight but even then you can use a coloured filter on the camera, though with a strongly-coloured filter the whole of the picture will be coloured.

It is more usual to use lightly-coloured filters: the most popular of these are the 81 series of 'warming' filters. They have the effect of adding a gentle golden hue to pictures and are popular for beauty photography. An alternative is to colour the light from your flash: many units have optional coloured filter kits. With computer controlled flash the light will be quenched after it strikes the nearest object, so you can use the techniques of fill-in flash to light your subject with coloured light, and still not affect the background.

** All photographic chemicals must be handled and used with care. Follow the maker's instructions carefully.*

Lay out all your material.

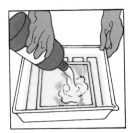
Place the print face up in the bleach and agitate until the image has nearly faded away (the amount you can see depends on the original density).

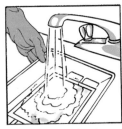
Wash *all* the bleach out of the print.

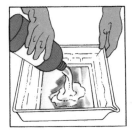
Place the print in the toner: the toned image will come up immediately. Afterwards wash thoroughly.

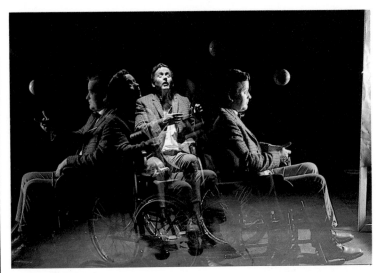
Coloured light
By using different coloured filters over the flash for each part of this multi-exposure picture, Michael Langford created a startling portrait of a man in a wheel chair.

Sepia toning
A simple two-part
toning kit was all that
was needed to create
this charming
old-fashioned portrait.

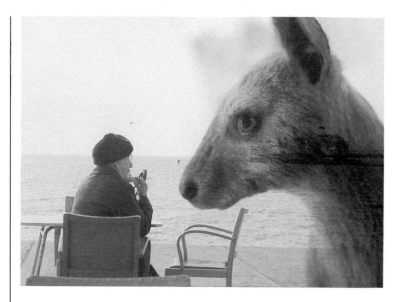

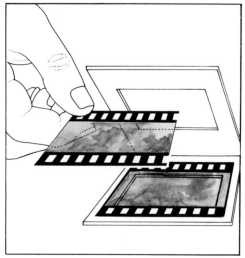

Sandwiching

To achieve successful results you need transparencies with large pale or clear areas so there is not too much overlapping. It is worth keeping rejected slides for sandwiching.

To sandwich two transparencies you simply mount them together in a plastic slide mount. Be sure to handle the transparencies only at the edges.

Sandwiching

By selecting two colour transparencies and mounting them together you can achieve startling results. It can take a long time to select two which are compatible and often you will have to take the pictures especially. Because you are placing them together both should be slightly over-exposed for a successful result.

Photograph a familiar object against a black background and slightly over-expose it so that the image is light. Now sandwich it with a straightforward picture of an unusual material: the familiar object will now seem to be made out of the material. All these sandwich techniques are best used on transparency films, and a certain amount of experiment will be needed to settle on preferred exposures and techniques.

Projection

With a slide projector and some suitable slides you can create a fantasy world of unnatural backgrounds and surreal effects. Unexpected results can also be achieved by projecting a transparency on to a light-coloured object and then re-photographing it. Because of the relative dimness of your projector bulb you will need long exposures; since your projector light is probably tungsten, use a tungsten-type film, or a correcting filter on your camera if you are using transparency film to avoid a yellow cast. Use your camera's metering system to measure the exposure from the slide.

It is successful to back-project a background. To do this you need to project the slide on to some translucent material such as tracing paper. Use a frame of some kind to make sure it is flat and at right angles to the projector. Make sure no light from the front falls on to the screen, as this will diminish the picture; use cards to shield it from lights An egg makes an unusual 'screen'. You can project a transparency on to a person's skin. Because of the long exposures involved, this method is not satisfactory for photographs of people.

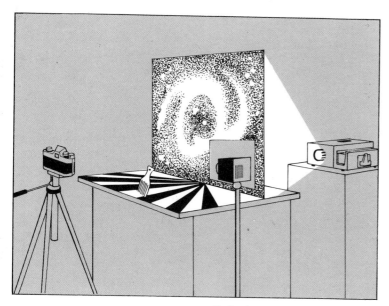

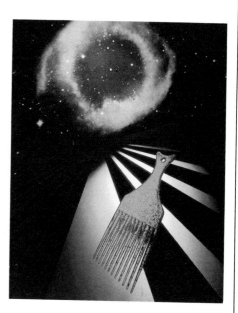

Projection
A slide of a nebula was projected on to tracing paper to create the background for this surreal photograph of a comb. The comb was lit with flash with the tracing paper carefully shielded and a long exposure set to record the slide. Using daylight film gave a yellow cast to the tungsten light from the projector, which could have been filtered if required.

CLOSE-UPS

Close-up photography can take you into new worlds invisible to the naked eye. Accessories are available to give magnifications of up to $4\times$ lifesize: at that enlargement a ladybird will fill your viewfinder.

Whilst close-up photography is possible with most camera types, the 35mm SLR is by far the best: since you frame and focus through the lens you can achieve far greater accuracy than with other types.

With any close-up system you get a very small depth of field and will need to use small apertures to give you satisfactory sharpness over your subject. Unless you are using flash, this will mean long exposures, so a sturdy tripod is a necessity: for pictures outside you may find a conventional tripod limiting. You need to get very close to your subject, so a tripod with a beam arm or one that you can reverse to mount the camera underneath is better. For pictures you set up inside, a small table tripod or camera G-clamp will be more useful than a conventional tripod. A cable release will help cut down unnecessary camera movement.

Some cameras have interchangeable viewfinders allowing right-angle viewing; if you are doing a lot of close-up pictures these will be very useful.

There are four main types of close-up attachments. Since all lenses give their best results in the middle apertures, you should try to use these when doing close-ups.

Supplementary close-up lenses.

Close-up lenses

These are additional lenses that screw on to the front of the camera; they suit both compact and SLR cameras and are normally available in three magnifications: $+1$, $+2$ and $+3$ dioptres, with the higher number giving the greatest magnification. The actual magnification depends on the lens you have on the camera, but they will give you up to $\frac{1}{4}\times$ enlargement. You will suffer some image deterioration, especially if you use more than one at a time.

Macro lens

This is now used to describe normal lenses with the facility to focus very closely. In many ways they are ideal because they can be used for normal photography as well. They will give a magnification of 1:1 and do not need any exposure compensation. A *macro facility* on a lens means it will focus to about $\frac{1}{4}\times$ magnification.

Mini-tripod
A mini-tripod is a low-cost alternative for supporting your camera for close-up photography.

50mm lens
This is the biggest magnification you will be able to get with a 50mm lens. The butterfly measures $2\frac{1}{2}$ inches across.

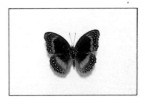

Supplementary close-up lens
This is as close as you would be able to get with a supplementary close-up lens on a 50mm lens.

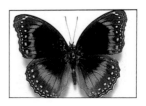

'Macro' lens
1:4 is the usual maximum enlargement with a macro lens.

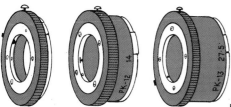

Extension tubes

Extension tubes
Extension tubes can be used with any lens.
With a 50mm you can achieve a ratio of 1:1.

Extension rings

These will only fit cameras with interchangeable lenses; they achieve
their effect by moving the lens away from the camera. The automatic
type are more expensive but they do connect up your camera's full-
aperture focusing system. With the cheaper, manual, rings your
viewfinder will get darker as you reduce the aperture: they are
simply a hollow tube and there is no image deterioration. They work
best with an aperture-priority camera. If your camera has not got
through-the-lens (TTL) metering you will have to calculate the ex-
posure (*see* box). They give up to life-size magnification.

Bellows

This very expensive scientific close-up attachment has variable
extension between lens and camera and gives a magnification of up to
$4 \times$. Exposures must be calculated on cameras with TTL metering.

Bellows
A bellows will give you 4x life-size enlarge-
ment, but the depth of field is so small that
the picture has gone out of focus on the
curve of the wing.

Exposure

No exposure compensation is needed with macro or close-up lenses
in either daylight or flash, but light has to travel farther when the lens
is moved away from the film, so with extension rings and bellows you
must allow more exposure to compensate. Cameras with TTL metering
will allow for this in daylight but flash settings will be wrong;
cameras without TTL metering will need exposure compensation for
both daylight and flash. Cameras with film plane metering of flash
will need no compensation with dedicated flash units (*see* p. 36).

Exposure compensation:
1. Measure the distance from the front of the lens to the film plane
symbol (ϕ) on the top of your camera.
2. Divide this by the focal length of your lens and square the result:

$$\left(\frac{\text{front of lens to film}}{\text{focal length of lens}} \right)^2 = \text{exposure factor}$$

e.g. 50mm lens on extension tubes that put the front of the lens 100mm
from the film:

$$\left(\frac{100}{50} \right)^2 = (2)^2 = \text{Factor} \times 4 = +2 \text{ stops.}$$

3. Increase exposure by required amount.

NB. Flash computers will be unreliable at very close range. Switch to
manual and set the unit at the minimum recommended distance.

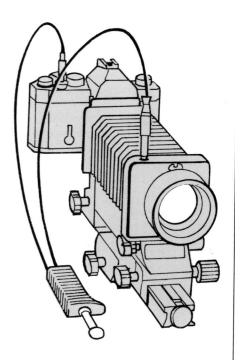

FILL-IN FLASH

One of the most useful photographic techniques is filling-in shadows with extra light. It is a way of controlling contrast – the difference between dark shadows and lit areas – using either a reflector to redirect the available light, or using your flash gun.

There are two main advantages in using fill-in. On bright, sunny days you can pose your subjects with their back to the sun so that they don't have to screw up their eyes in the bright light; since you will be shooting into the sun in this situation, you must use a lens-hood on your camera or the light will flare your picture and spoil it.

The other benefit is that you keep all the detail in your pictures by avoiding harsh, black shadows whilst retaining the modelling that gives a photograph a feeling of depth. For this reason, fill-in light must never be as strong as the available natural light.

Reflectors

A reflector is just that: it reflects the available light back into the darker areas of your picture. It can be anything that is light-coloured. At its biggest it can be the light-coloured wall of a building – the white-painted buildings of the Mediterranean act as reflectors all day long. You will often find that this softer reflected light, out of the strong sun, is more pleasing for holiday portraits.

On a more manageable scale, a white pocket handkerchief will do in an emergency, but the most useful will be a home-made reflector about 3′ × 2′. White card or material is best: colour will add that colour to the light. Thus a yellow reflector will give a yellow cast to the light: a green wall will give everything a green colour. If you use white card, cover the other side with kitchen foil; crumple it up and smooth it out before sticking it to the card. This will give a different quality light from the white card on the other side.

You can buy reflectors that fold up for convenient storage; as well as white and silver, they are available in gold material: the touch of

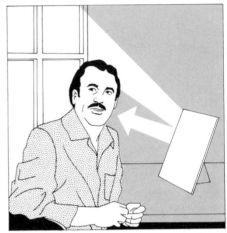

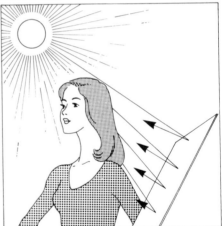

Windows
A white reflector or mirror will give extra modelling for subjects posed near windows.

Shadows
The black shadows created on a sunny day can be lightened by using a reflector or by positioning your subject near a light-coloured wall.

Reflectors
Positioning Paul Hogan against the bright sunlight so he didn't need to screw up his eyes gave too much shadow on his front. A silver reflector pushed back enough light to give a perfect exposure.

gold in the reflected light makes a face look slightly sun-tanned and healthy.

The problem with using a reflector stems from providing it with support in the right position; it is best to get someone else to hold it, or else fix it to a stand or tripod. Sometimes you may get your subject to read a book or newspaper that will act as a reflector; with babies and pets, you can pose them on a light sheet or blanket. Small card reflectors on little stands will be invaluable for close-up pictures.

Fill-in flash
Don't be afraid to use your flash to lighten the shadows on a sunny day, but be sure to set a correct speed on the camera for synchronizing with the flash.

Fill-in flash
Fill-in flash has given the impression of bright sunlight on this gondola party, even though they were in the shade of the high buildings. In this case the flash was set to the working aperture, but it is often better to set it slightly lower.

Fill-in

Because a reflector uses the available light it will always give a weaker light than its source. This is not the case with fill-in flash so you will have to take great care in balancing the two sources. It is not easy to perfect the technique but it is well worth the effort.

The first thing you must do is set your camera to its flash synchronization speed; with most 35mm SLR cameras this will be 1/60th or 1/125th. Now take an exposure reading of the whole scene using your camera, and set that aperture on your lens. The art with fill-in flash is to get the flash gun to produce less light than the sun. There are several ways of doing this. If you have an automatic flash gun you can either set the flash for an aperture two f-stops larger than you will be using to take the picture: if your camera is set to f8 you would set the flash for f4. Alternatively, you can change the ASA setting on the flash to a faster film speed, and use the same aperture on the flash as on your camera: if you are using 100 ASA film, set the flash for 400 ASA and use the same aperture as set on the camera. Be sure to turn the ASA setting back afterwards or you will underexpose ordinary flash pictures.

With manual flash units you should position the flash further away than is recommended. Look at the data on the back of the flash and choose a suitable distance using the principles above. If necessary take your flash away from the camera, using a flash lead. With simple cameras just use the flash as normal or slightly further away than is usually recommended.

AUTO-WINDERS

Many cameras have the facility to wind on and re-wind the film automatically; in some cases this is built into the camera, or you can buy the unit as an accessory.

Auto-winders

An autowinder, whether built-in to a compact or 35mm SLR camera, or as an accessory for a 35mm SLR, will wind on the film and re-cock the camera automatically after each exposure. It will take only single exposures, so you have to press the shutter each time you want to take a picture. They will normally give a rate of 1–2 frames per second (fps).

Motor drives

Motor drives are normally available only for expensive 35mm systems. They have two settings. *Single* is the equivalent of a winder with the photographer pressing the shutter release each time; *continuous* keeps the camera firing whilst the shutter release is depressed. Depending on the speed set on the camera, a motor drive on 'continuous' can achieve rates of 5–6 fps.

Unless you have a specific requirement for fast sequential photographs, you will not need a motor drive; at its maximum a motor drive will expose a standard 36-exposure film in 6 seconds. Winders are useful, particularly for photographing children, where expressions and moods change from second to second. Because you do not have to take the camera away from your eye to wind on, you can concentrate totally on watching your subject. The same applies to portraiture: with your camera and winder mounted on a tripod, you can come from behind the camera and talk to your subjects, making an exposure whenever they look right.

Winders are also useful for photographing fast-moving sports events, enabling you to follow the action, knowing your camera is always ready. Their smooth movement is also useful in close-up photography. For nature pictures rig your camera for remote operation; although winders are noisy they are less likely to disturb animals than a human presence. Although complicated remote controls are available, a simple bulb release will be adequate for most situations.

You must use winders and motors with caution, or you will expose too much film. They also use a lot of battery power, so you should carry a full spare set with you. They are normally supplied only by camera-makers, but some independent brands are on the market.

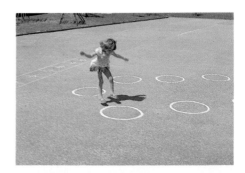

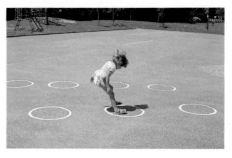

Auto-winder
Using an auto-winder meant the photographer didn't need to take the camera away from his eye as this little girl played, and he was ready for the second shot.

Motor drive
A motor drive was the only way to be sure of capturing the high-speed action as this boy puts his BMX bike through its paces.

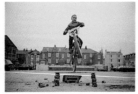
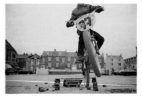

SUBJECTS

BABIES AND TODDLERS

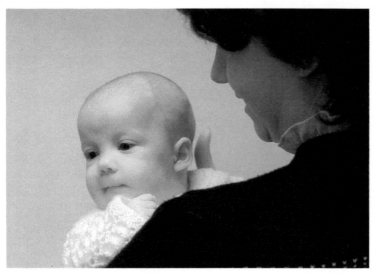

Natural light
The gentle soft daylight gives a
delicate feel to this picture,
emphasizing the bond between
mother and child.

The changes children go through in their first two or three years are
the most dramatic of their whole lives, so it is important to photograph
the period as fully as possible. The immediate family, as well as
grandparents and friends who live far away, will relish frequent
photographic progress reports on new additions; a good set of grow-
ing-up pictures will provide hours of enjoyment even for their subject
in years to come.

The selection of backgrounds and viewpoint is still important when
photographing babies and toddlers, but don't let this stop you getting
the pictures: the nicest shots will be natural ones and you will lose
atmosphere if you attempt to pose them or take too long in getting
the picture. Babies grow so fast you should make it a rule to take at
least one picture a week.

Candid shots will be best: as weeks go by the growing baby begins
to develop a world of its own, so your most successful efforts will be
those where you managed to capture unexpected reactions to a new
experience. It might be bath time, or the first faltering steps clutching
mother's finger. To be successful you must have a camera, loaded and
ready, near you, all the time: obviously you will miss the special
moments if the camera is put away in a cupboard.

The art of photographing this period is to see yourself as a story-
teller. Your story should begin before the birth of the baby. As the
mother-to-be becomes more obviously pregnant try to photograph
her in moments of repose. Natural light will be the best; this is a good

Bathtime
Most babies are relaxed after baths
and meals.

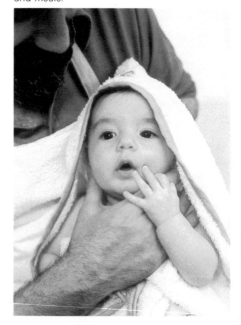

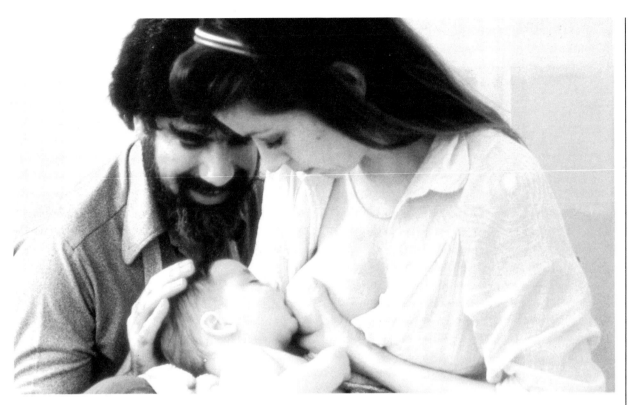

time to use a diffusing filter for a 'soft' effect.

You will need permission to take pictures in hospital and it is unlikely you will be allowed to use flash. Very fast 1000 ASA colour negative film will be useful here; the light source in hospitals is usually fluorescent tubes, but 1000 ASA can cope with the green cast which that lighting gives pictures. Slide film will have a cast unless you use a magenta filter.

As well as general shots over the baby's first months you should try to set up a series of pictures showing physical growth. To do this you will need to pose the infant in relation to something permanent. A cot may be sold or given away so try to use a piece of furniture that you will keep, or something even more permanent like a door or a wall which can be used in the same way over years rather than just months. When it is very tiny you can emphasize how small it is by including a grown-up hand.

The baby's development of skills should form part of your story: life over these months will be full of 'firsts'. The best time to get your pictures will be when the baby has been fed and rested. At about 4 weeks the baby will start to smile, its eyes will focus and the face become more interesting: try to get close so that the baby's face fills the frame. Don't forget pictures of tears and sleep as well.

By 6 weeks the baby's eyes will follow activity; at three months it should push itself up and raise its head to look at the camera. Get yourself ready to take a picture, then get someone to attract the baby's

Everyday moments
Keep your camera handy; moments in the baby's daily routine are worth recording too.

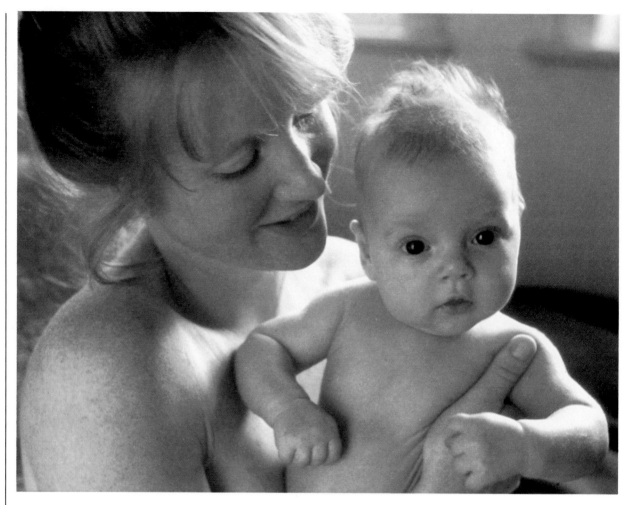

attention in the direction you want it to look. Over the next few weeks the baby will become more aware of its surroundings; at 7 months it should be sitting unsupported.

Instead of looking down on the baby, try to get down to its level, or bring the baby up to yours, either by placing it on a table or by getting an adult to hold it. By a year old the baby will be able to stand with something to hold on to and by 18 months it should be walking. You will need a faster shutter speed than normal by this time, to make sure the child's movements aren't blurred on your pictures. Try 1/125th or 1/250. Above all you will need your camera on hand; you will have to be patient and will use more film than normal, but your efforts will be rewarded. A winder will be useful because it saves you having to take the camera away from your eye to wind on and re-cock the camera – you can keep your concentration on the baby.

Although daylight is the most beautiful you will have to use flash at times; try to bounce it. Bounced flash has similar qualities to bright overcast daylight and will not give the hard black shadows produced

Support
Using the mother to hold the baby for a picture not only supports it but emphasizes its tiny size.

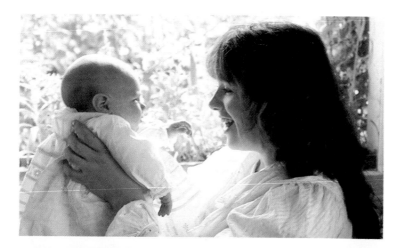

Development
After 6 weeks the baby will respond
to people, as this touching picture
by Anthea Sieveking demonstrates.

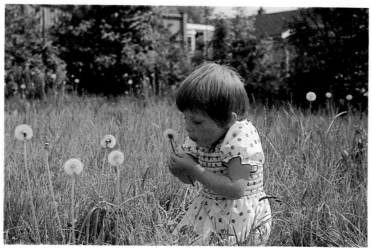

Viewpoint
By getting down to a child's level
you will be much better able to
record the child's world.

by direct flash. The baby's clothes and cot linen will act as natural reflectors when it is lying down, but you might have to fill in the shadows once it starts to sit and move.

There is no correct lens for photographing babies and toddlers. A short telephoto lens will be useful for 'candid' shots without disturbing the child; its narrow depth of field will also help control untidy backgrounds, but you must be careful to focus accurately. A wide-angle lens will be equally useful for play pictures; if the child is playing in the garden a wide-angle will let you include your house in the picture as well, but don't get too far away from the child or it will appear very small in the picture; be careful also about the distortion a wide-angle produces.

Instead of trying to take formal portraits of babies and toddlers you can arrange a casual shot. By placing 'props' such as a new toy or some dressing-up clothes in a well-lit position you stand a good chance of getting a good picture. But remember that with young people nothing is ever predictable!

Photographing babies
Use cushions or a chair to support
babies up to about 6 months old. By
mounting the camera on a tripod
and using a cable release you will
be able to watch the child and press
the shutter at the best moment.

PETS

Pets are part of the family, so whenever possible make up a little group of the pet with a child or grown-up. In addition, the pet will be easier to control if it is accompanied.

The rules for photographing pets are very similar to those for photographing small children: really worthwhile pictures result from spending lots of time and patience watching and waiting for the right moment. Preparing your equipment beforehand is essential – like children, most pets have a very short concentration span, and by being ready with film and flash you will avoid missing those first fresh looks.

Pets are very much creatures of habit. You may be familiar with your own pet's but if you are asked to photograph someone else's pet it may take a little time to find out something about them. Most cats and dogs have favourite places for sleeping, and favourite pieces of furniture for sitting on. Using these familiar haunts for your pictures can re-assure an excitable pet.

As with children, your pictures will be more successful if you can fill the frame with the subject. A short telephoto lens (range 85mm to 135mm) or a zoom with a similar range will enable you to avoid coming too close and disturbing the animal. The added advantage of these lenses is that they will give nicer proportions to faces, and the narrow depth of field will help eliminate distracting backgrounds.

The biggest problem in photographing small animals is getting close enough, something virtually impossible without one of the close-up accessories. A lens with a close-focusing or macro facility would be best.

Be sure to focus carefully. The eyes are the best part of a subject to focus on normally, but you may have trouble if a dog has a long muzzle. If you are close, get the dog's face parallel to the camera.

A faster film (400 ASA) will give you the fast shutter speeds you need for an active pet. With a sleeping or more docile subject a 64–100 ASA film will be sufficient.

Cats

The position you take the picture from is very important with cats. Try not to look down on them; a picture from 'cat's eye' level will be much more successful.

All cats are very private individuals with a set routine; you will be an intruder into this. It will be very difficult either to pose a cat or to move it to a location it doesn't like, but you can tempt it. A warm hot water bottle placed under an attractive blanket will induce the cat to stay there for as long as you want, but be sure to choose a blanket that suits your need for a background.

You can also use food as an inducement for obtaining unusual pictures of cats and kittens. A favourite morsel buried in a wool basket will encourage them to search for it, often with hilarious results; put a little butter on a paw, and the cat will lick it off.

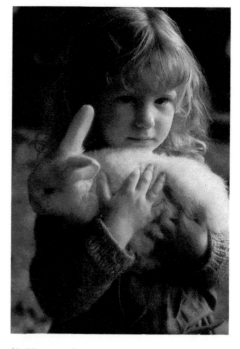

Holding small pets
You will get more successful pictures of smaller pets if they are held. It emphasizes, too, that pets are part of the family.

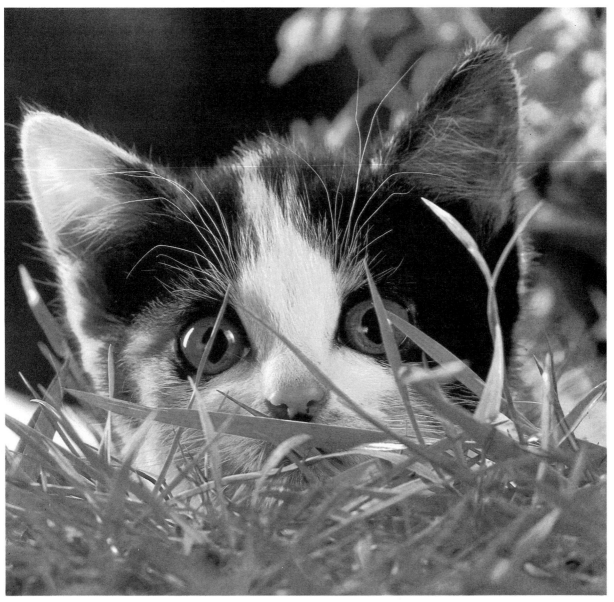

Try not to use flash; a cat's eyes will invariably produce a 'red-eye' result in your pictures. If there is not enough light and you have to use flash, try to bounce it off a wall or reflector. When you are ready to take your picture a sharp noise from near the camera will attract the cat's attention, but you will need a fast shutter speed to freeze any movement. With simpler cameras you will need to wait until the cat is at rest, often after its meal. Alternatively, you could get someone to nurse the cat and stroke it. Your biggest problem will be getting close enough – and be careful not to get closer than the camera can handle.

Attention
A bunch of keys on a string was jingled just over the camera to attract the kitten's attention. Focusing and depth of field are critically important when taking close-up shots like this of pets.

Dogs

Dogs are much easier to photograph than cats: a well trained dog is as easy to pose as a professional model but, especially when young, they can tire and get bored. They are generally most amenable after a meal.

Backgrounds must be looked at carefully to avoid distractions for the animal, and yet be big enough to work with a large dog. Outside locations will be more suitable than indoors as a rule, though with outside locations it's likely that the dog will run about if you take too long.

Puppies obviously tend to be more unruly and you will have more success if you can confine them. Their basket is an obvious place but look around for more unusual ideas. Shopping baskets, vases and even saucepans will work very well but be ready to take the picture before you put the puppy in. Then you can attract their attention and take the picture before they begin to get restless.

If you are going to take a portrait shot be sure to clean away any discharge around the dog's eyes. Set up your shot, then get a friend to attract its attention in the direction you want it to look.

Dog shows will give you a totally different set of opportunities. If you are photographing a pedigree dog and don't know the breed, get the owner to tell you the key points and make sure you show them. Use a large aperture to reduce the depth of field so that the picture concentrates on the dog. Then wander around the whole show area: you may have the chance to take humorous 'candid' shots of dogs with their owners. These pictures often work better in black and white.

Timing
By waiting till the dog was resting after a run in the field the photographer had lots of time to get this beautiful portrait. Just enough depth of field was allowed to keep the dog in focus but to have the foreground and background blurred.

Exposure
An uncomplicated picture such as
this, by Anthea Sieveking, requires
careful assessment of exposure from
the goldfish bowl.

Smaller pets

Smaller pets are seldom as trainable as dogs or as settled as cats, but
if you can control them your pictures will be as charming. Use the
same principles as with puppies to limit their area of movement:
depending on their size a cup or bowl set on a suitable background
will be perfect. Again you must be ready to shoot before you place
the pet inside. A little food in the container will keep them occupied
for a few moments; you could even build a small 'set' for them out of
rocks and bits, with some food hidden in it. But the easiest way with
small pets is to get someone to hold them, particularly attractive if the
someone is a small child. Then get another helper to hold some food
out of your picture but from the direction in which you want the
animal to look.

Birds

The problem with pet birds is to get a picture without losing them.
If they are very tame you will be able to take them out of their cage
and sit them on the back of a chair; better still you could build a little
set with a perch and a blue background. Again, you must prepare
beforehand, because your time will be limited. With caged birds try
to replace the cage-front with glass. You can 'lose' the bars of a cage in
a photograph by carefully controlling the depth of field, but it is not
always entirely satisfactory: replacing the bars with glass and adding
a blue background at the back of the cage will give a more natural
look to the pictures. Allow light to come in from the top and sides. If
the weather is overcast you will avoid shadows from the bars, but if
it is sunny fix some tracing paper to the outside of the cage to diffuse
the light. With glass in the front you will have to be careful of re-
flections; if they become troublesome cut a hole in a large piece of
black card and push the lens through this.

INDOOR SPORTS

With all sporting events it is an advantage to have some idea of what is going to happen so that you can plan your shots and be in a good position for the action. This is particularly important with indoor sports because you will often be confined to a seat. Before you book, go to the hall and see which seating area will suit you best.

Lighting will be a problem. Most halls are lit with tungsten light so you will need to use film designed for that. The limitations of the lighting and the need to freeze the action also make it preferable to use the fastest films available: even if you were close enough to use flash, it would be unfair to the participants to distract them in this way.

Squash courts are often lit by fluorescent tubes which will give a green cast to your pictures. If you are taking transparencies you can correct this with a special magenta-colour filter, and you should seek the advice of a specialist retailer. Colour-print film can be compensated for fluorescent lighting at the printing stage.

If there is a gym or sports hall near you it would be better to approach any clubs that meet there for permission to take pictures during training. This way you could use flash since the athlete would be expecting it, and you could get pictures from unusual viewpoints that would be impossible during an event.

Pauses
Even the simplest cameras can get good pictures when the action stops, as in this picture of a weightlifter.

Concentration
You need to concentrate and follow the action closely to get good pictures at indoor sports events.

Look carefully at backgrounds. Some events like weight-lifting take place in front of a scoreboard which can add a strong element to your picture, but if the background is intrusive there is no alternative but to move to a better location. Be careful about bright lights shining towards you: they can adversely affect your exposure and cause flare on your picture.

Your lenses may also give you problems. The need for fast shutter speeds will often mean using them at their maximum apertures – no lens gives its best results at these extremes, so try to close the aperture by one or two stops.

A good telephoto lens of 200mm or 300mm will be necessary to give you a big enough picture of most events. It will be impossible to use a tripod, so try to use the back of the seat in front or the side of a pillar for support. It will help to rest the lens on a bean bag or a pair of leather gloves.

All sports shots do not have to be pin sharp: many activities have movements that lend themselves to long exposures, bringing out the graceful patterns the participants make. And don't forget that there are many things going on away from the main activity: athletes waiting on the sidelines or relaxing; the brightly-coloured equipment and the spectators are all a rich hunting ground for pictures.

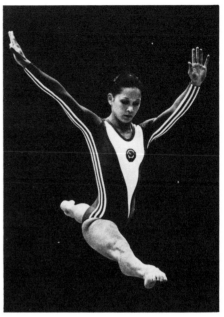

Clubs
You may not be able to take pictures like this at major sporting events but many clubs will let you take pictures during training.

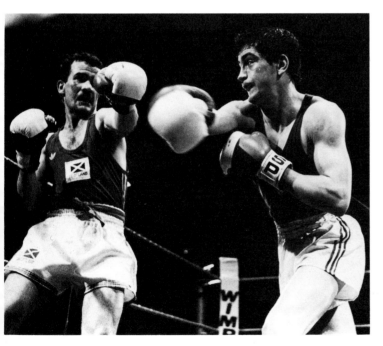

Position
You will be unable to move in many indoor sporting events so you should choose your position carefully.

Action
A knowledge of the sport will enable you to pick a location where the action is likely to happen.

CONCERTS AND PLAYS

Concerts

You are not always allowed to take pictures at pop concerts so check first; your main problem will be to get a seat with an unobstructed view. For any big concert a telephoto lens will be needed if artistes are to be identifiable. Only the most expensive telephoto lenses have large enough apertures to use conventional film safely without a tripod. With groups that play in clubs and pubs you can get much closer and select individuals. Flash would destroy the concert atmosphere but even a very powerful unit lights no further than 30 feet. Most pop concerts have elaborate light displays, so it is better to use this light. To get the greatest benefit from stage lighting use fast film: Kodacolor VR1000 for prints or 3M 640T for transparencies are fastest.

It will be hard to get an accurate exposure-reading the further you are from the lit area. Automatic camera metering takes account of the whole picture-area to achieve an average; with a brightly-lit area surrounded by darkness, it will over-expose the bright area to compensate for the darkness. Unless you can get near enough to take an accurate reading, set your compensation dial to −2 or your ASA dial to $\frac{1}{4}$ of your film speed (400 ASA to 100 ASA). If you do change your ASA dial, change it back afterwards. The brightness will constantly change so an automatic camera is better: once compensation is set, it will allow for any variation in light level.

Concert halls
Be careful when taking exposure readings: try to fill the viewfinder of your camera with the lit area of the stage.

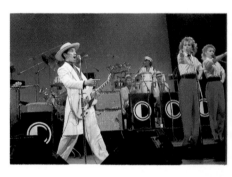

Pubs
Whilst you may not be allowed to take pictures in concert halls you will find many pubs and clubs are not only more amenable, but you are able to get much closer to the musicians.

Plays

You need permission to take pictures in professional theatres. Most managements rightly forbid this during performance: flashes and shutters clicking would distract both actors and audience, so confine your theatre pictures to school and amateur productions.

You will get better pictures if you can arrange to take them at a dress rehearsal. With the help of the director you might even be able to set some up specially. If you can do this you should be able to get most of the pictures you want using a normal lens, but some amateur stages are very small and a wide-angle lens would be useful if there is not much space to work in. If you can take pictures beforehand don't confine yourself to the full stage; try some portraits of the actors in their costumes and make-up. If you have to take pictures during performance use a telephoto lens from the back of the theatre: you look up too much from the front row.

Amateur stage lights are not usually very bright, so use a fast film. Tungsten bulbs, such as those used in spotlights and floodlights, will give a yellow cast to your pictures, particularly with colour transparency film, so you should use one of the films designed for tungsten light, usually designated as 'T' or 'artificial'. Negative films are also designed for daylight use and will have a yellow cast, but the processor can remove most of this when he prints your pictures. It is a good idea to tell him about the tungsten light pictures when taking your film in to be developed.

Whenever you take pictures try to fill your viewfinder with the stage for the exposure reading, otherwise the darkness surrounding the bright area will cause your camera to over-expose the stage. If you cannot do this, set your compensation dial to − 2 stops.

Theatres
The taking of photographs in professional theatres is strictly controlled, but amateur and school productions will give a rich variety of subjects. This picture was taken on fast film with available light because flash would have killed the atmosphere.

GROUPS

Often when people meet together they want a memento of the occasion. Whether a family wedding with friends and relations who have not met for some time, a local sports or interest group, or simply a relaxed day out, a photograph has become the expected keepsake for all the participants. Technically the problems of photographing a group are little different from any other picture; posing and controlling a number of people provides the problems.

There are two broad types of group pictures: the *formal* group, more suitable for a family portrait or a large number of people; and the *informal* group, with a much more casual and relaxed atmosphere.

For either you must choose your background carefully. If you are taking a formal group picture outside, it is worth having a look before anyone arrives for a suitable position; with a family portrait indoors, it may be necessary to fix up a background if there is no suitable plain wall. An informal picture is easier in this respect and often it is nice to use something that indicates the common bond, say a corner of the pub as background for the local darts team.

When you are selecting a position bear in mind the number of

Environment
Many group pictures can be enhanced by using the work or recreation environment as a setting.

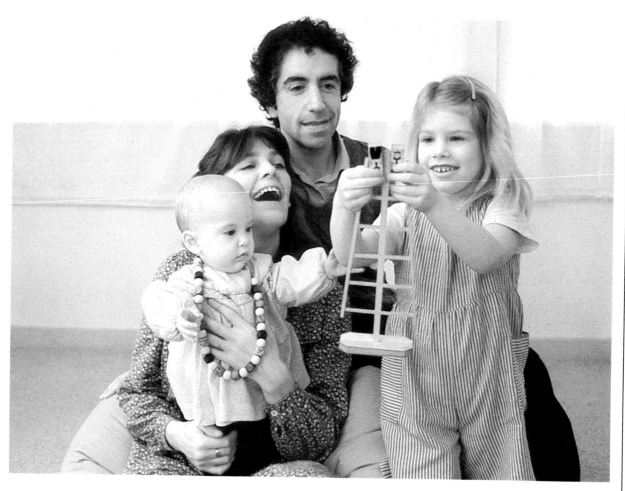

people you are going to photograph. Everyone will expect to be seen, so a sloping position will help you if there are lots of people, perhaps a grassy bank outside or the stairs in a home. You can 'build' a family group around an armchair or sofa, or it may help you to get higher, and look down on the group (this can also be useful if there is not a suitable background).

Whichever type of picture you are taking, you must add the people to the background as carefully as a painter would. It is a good idea to have a plan of how you are going to place people. Apart from certain conventions, such as wedding groups, try to avoid putting them in a straight line: you will get a more memorable picture if you can create a closer shape. With a formal group there will usually be a focal point – mother and father in a family picture – so position them, and then position the others around them. Be as fast as possible – people get tired and bored if you take too long.

Posing an informal group is, in its way, harder. You must still position people to give the composition you want, but you must try to make it seem accidental. One of the best ways is to give people

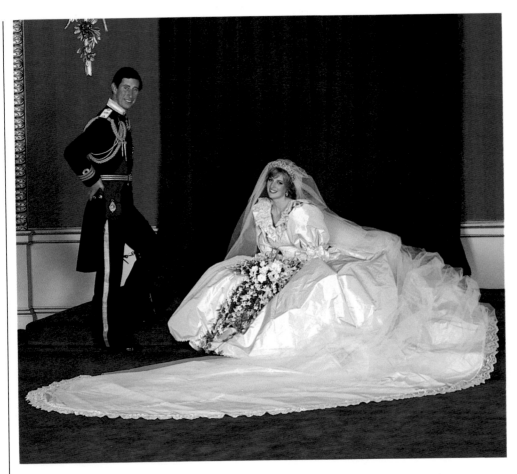

The Prince and Princess of Wales
When photographing people the photographer must try to set a relaxed atmosphere. Careful preparation before they arrive avoids off-putting delays.

something to do: the lighting of the birthday cake candles should take everyone's attention away from you. An informal group does not mean that the subjects should not look at you, but that they should be relaxed; props will help: a new car is an ideal setting for an informal group.

A 28mm or 35mm wide-angle lens is often necessary when you have to photograph inside the house, or in a restricted space. With a 50mm lens you can often move back to get everyone in but this is less easy inside. The greater depth of field of a wide-angle can also help you: to photograph the family around the Christmas lunch table you can climb on a chair to get some height, then the wide-angle will get everyone in, and in focus. Having everyone in focus is very important and it may be worth changing to a faster film for the extra aperture.

Don't position people facing the sun for an outside picture: they will only screw up their eyes and become uncomfortable very quickly. Turn their backs to the sun and either take an exposure reading off their shadowed side or, if the contrast is too great, use fill-in flash and expose for the background. An overcast day is always much better than bright sunlight for photographing people outside.

Location
The wooden panelled corner with the table as a centrepiece formed an ideal setting around which to position this group of SDP ladies in Patrick Lichfield's picture.

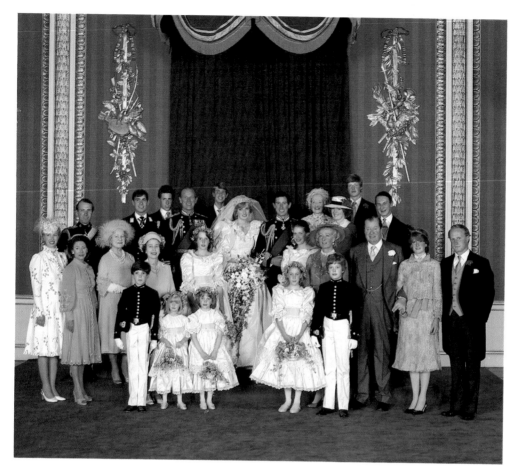

The Royal Wedding group
Patrick Lichfield utilized the dais of the Throne Room at Buckingham Palace to make sure all the guests could be seen. He had worked out all the positions beforehand and used a whistle to attract their attention when he was ready to take the picture.

Be careful when using a single flash indoors: if your subjects are different distances from you, you will get uneven light with direct flash. You will get a better and more even light if you can bounce it off a light-coloured wall or ceiling, which will also spread the light to suit a wide-angle lens. It is much better if you can use more than one flash for a more balanced-looking picture (*see* p. 72).

You will find that a tripod helps with formal groups: having set up your camera you can then watch and talk to the group over the top of it. When you are ready to take the picture you will need to get the group's attention. A loud noise will normally work: shout or clap, not forgetting to push the button (Lord Lichfield uses a referee's whistle). Don't be afraid to take several pictures of a large group, since the chances of everyone looking at the camera and smiling at the same time are remote. Always have film left in your camera: the end of a formal session will often produce humorous pictures as people relax.

By using your tripod and the camera's self-timer you can also get yourself in the group. Set the group up with a space for yourself and set the self-timer; when you activate the shutter you will have about ten seconds to position yourself in your space.

Setting
The steps of a French cathedral formed a naturally sloping setting for this informal picture of a band.

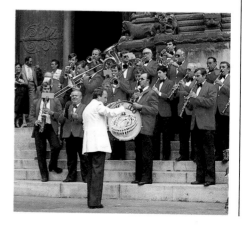

Lighting groups

To take a good family group indoors you will need more than one light. It may not be easy to borrow extra flash guns but you can buy powerful photographic light bulbs called 'photofloods' that will fit in an ordinary light fitting; these have the added advantage that you can see exactly where the light is going. They get very hot, so remove domestic shades and remember to use tungsten film for slides. To achieve a 'bounced' effect without the proper reflectors, place a small shiny reflector in front and a large white reflector behind the bulb. When using more than one flash unit you need small 'slave' units to fire other flashes simultaneously.

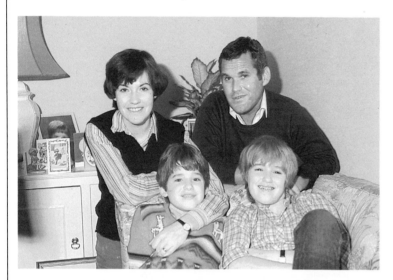

With the first shot, taken indoors using a standard lens with the flash mounted on the camera, the lighting is very harsh and has caused hard black shadows. There has been no attempt at posing and the boy's clothes are out of keeping with the rest of the family's. The background is also very distracting.

By moving to another part of the same room there was a much better background. Seating mother and father in a chair with their children posed round them has created a more pleasing composition, enhanced because the boy has changed his clothes. By changing to a 100mm short telephoto lens, the group now fills the frame. Taking the flash away from the camera on a lead and bouncing it has given a softer light with more modelling, but the shadows are still too dark. This light is called the *main light* and is set to give enough depth of field for everyone to be in focus.

Adding a *fill light* removes the shadows; by having it dimmer than the main light you keep the modelling on the faces. The background is still too dark.

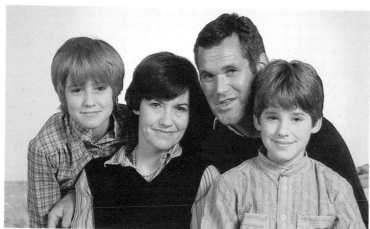

The finished picture. A light has been added, hidden by the family, to brighten the background.

Arrangement of lights

1 Main light. Base your exposure calculations on this light.

2 Fill light. This should be set to give less light than the main light. Two sheets of tracing paper were used in the final example to reduce and diffuse the light.

3 Background. Make sure that this is hidden by the group.

BAD WEATHER

Most cameras are used to take pictures only in sunny weather: once autumn arrives the camera is put away until next summer, except for a brief appearance around Christmas. The reason is obvious: overcast, wet winter weather seems to offer no inducement to go out and take pictures.

Yet the different light that comes with bad weather changes the emphasis of everything we look at, and presents a completely new set of opportunities for photography. Nature's colours become muted; people change into bright rainwear; fog and mist create fantasy landscapes that are real and unreal at the same time; the harsh contrast of the summer sun softens to a gentle, even light. With a little care all this can be photographed.

The most important precautions to remember when taking pictures in bad weather is to protect both yourself and your camera. If you are cold and wet you will be disinclined to think about what you are doing and will inevitably be disappointed with the results. Wear an anorak or coat that is big enough to have your camera inside it, and with enough pockets for your film, flash and other bits. Wear an extra pair of socks inside your boots. You often have to wait for a good picture and you will lose your concentration if your feet are cold. Fingerless mittens or thin inner gloves will help you work your camera: it is very difficult to handle the controls wearing heavy gloves.

Keep the strap of your camera around your neck; it is too easy to fumble with cold fingers and drop it. There is no need to protect your

Dull
The flat light on a dull day contributes to this study of a man and his dog walking on a beach.

Rain
You must make sure your camera is protected when taking pictures in rain storms.

Ice
The patterns and shapes of ice and frost make subjects for close-up studies, as in this picture of alder branches by Heather Angel.

camera particularly in normal cold weather, though batteries will be less efficient in the cold, and it is worth keeping some spares in an inside pocket close to your skin so that they stay warm.

Take care when you are winding-on and re-winding your film in the cold: it can become brittle and either snap or cause a static discharge if you move it too rapidly.

The time to be careful in cold weather is when you go back inside. You must brush off any snow as soon as you are sheltered; going from the cold into the warmth will cause condensation on your camera which can lead to problems. It is better to put your camera into a plastic bag and seal it, then the camera can come up to room temperature without attracting condensation.

You will encounter lots of problems in sub-zero conditions when the thermometer is reading $-20°$. You should seek specialist advice from your dealer if you are going to subject your camera to those sort of temperatures. Lubricants will need to be changed and modifications made.

You will need to protect your camera against heavy rain. The easiest way is to put it inside a large plastic bag: cut a hole to put the lens through and then secure the bag around the lens with a rubber band. A lens hood and ultra-violet filter will protect the front of the lens. Don't try to load film in the rain; wait until you are sheltered.

Fog
Tony Evans waited until a foggy morning obscured an unsatisfactory background to photograph these trees in Knapwell, Cambridgeshire.

Waterproofing your camera
A polythene bag and rubber band will give adequate protection from rain to the camera but use a lens hood to keep rain off the lens.

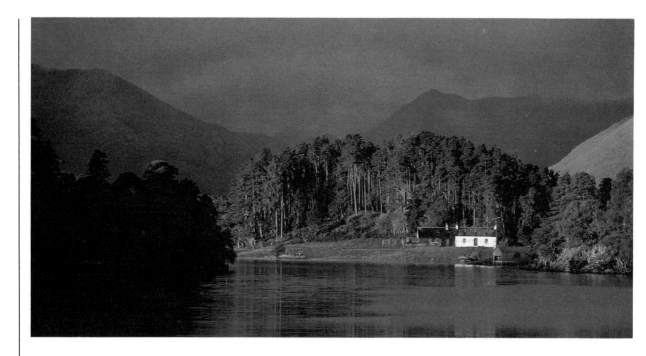

Storms
Patches of sunlight breaking through
the storm clouds provided a
startling contrast of light and dark.

You can buy water-proof cameras designed for use in adverse conditions. They are not designed for underwater photography but are safe to use when swimming and ideal to use in rain and snow with no protection.

Rain itself is hard to capture: you will need to face the sun to give it any definition. Instead, look for coloured umbrellas and raincoats, or try posing children inside by a rain-splashed window and either photograph from the inside looking out or *vice versa*. From the inside you will need to set your exposure for the daylight outside and turn their faces side-on to catch the light. If you are outside, get them to sit very close to the glass; if the window is misted up, just clear enough to see their faces.

After a rain storm the light will be very clear because the atmosphere has been cleared of dust. You may get sunlit foregrounds with the dark rain-clouds as a background. Look for reflections in puddles.

Some auto-focus cameras will be difficult to use in haze and fog. These are the types that use contrast comparison to focus. The lack of contrast is one of the difficult features of bad weather. Try to find another object to focus on that is the same distance away, and use the focus lock if you have problems.

Fog and mist change the outdoor perspective. Objects in the distance fade into each other; landscape becomes simplified and only the most dominant features stand out. An advantage of fog is that it can blank out an untidy background. Try to capture the atmosphere. The glow of shop windows and vehicle headlights will help paint a picture in towns. In the countryside try to incorporate the black outline of a nearby tree to give scale and framing to your picture. It

Water resistant cameras
Some 110 and compact cameras are
designed for use where sand or
water might come into contact with
them.

is difficult to get an accurate exposure reading and it will be safer to bracket.

Faster film has higher contrast as well as faster speed, so it has advantages for outdoor winter shots. Since it will also extend the range of your flash it is a good idea to use it for all your winter photography.

In snow you must take care when setting your exposure: remember that the built-in meter is striving to reduce everything to a mid-grey, which can lead to exposure problems. When the meter senses the brightness of a snow scene it will try to cut down the exposure, leading to *under-exposure*. Results will be more accurate if you make a substitute reading for the exposure from your bare hand. If your camera is so automatic that you have no control over exposure, you can compensate by turning the ASA dial down *by two stops*, setting it to 100 ASA if you are using 400 ASA film or 25 ASA if 100 ASA is loaded. This only applies outside: you must turn it back for more normal lighting conditions.

When it is actually snowing the light is very flat with no contrast. With a long exposure you can capture the flakes as streaks, but the best pictures are when the sun comes out. The sky can be very blue, especially on winter sports holidays, so it is a good time to use a polarizing filter. To photograph skiers you will need to pan your camera: the blurred background will further enhance the speed. Brightly-coloured clothes will be a feature in composition. Position people with their backs to the sun. If enough light is not reflected from the snow use fill-in flash, then they will not need to screw up their eyes, but you must use a lens hood.

Dull weather means very little contrast and no shadows, all natural colours seeming very muted. Because the light is so soft it is a good light in which to photograph people: skin blemishes and the lines of old age are less prominent. Strong-coloured objects will stand out in these conditions, so you must either use them in your composition or avoid them. The light will be rather blue and it may be necessary to use a weak 81 series filter with colour transparency film.

Strong winds bring the danger of camera-shake and you should increase the minimum shutter speed to 1/250th with a 50mm lens if you are hand-holding. If you are using a tripod you will need to anchor it down; a bag of stones hung underneath will suffice. With 'candid' photography watch for people struggling with umbrellas and hats in the wind.

Stormy weather is very dramatic. With black and white film you should use an orange filter to heighten the contrast. Watch for rays of sunlight coming through gaps in the clouds. If it is very dark use fill-in flash techniques when photographing people with the flash set to the full value.

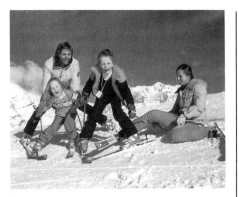

Snow
You must be careful when setting your exposure for snow pictures. A light reading from your hand will be the most accurate.

Winds
It will be very hard to hold your camera steady in a strong wind. Even a tripod can vibrate and should be weighted for extra stability.

GARDEN CLOSE-UPS

By far the most popular area for close-up photography is the garden; in the countryside, too, people have become more aware of nature's heritage and photograph wild flowers in preference to picking them.

As well as one of the close-up accessories you will need a good tripod: you will often need to make long exposures in difficult positions so the camera must be firmly supported. It is difficult to get close to low growth with a standard tripod, therefore one with a reversible column or with a boom arm is preferable. In your own garden you can use a miniature tripod on a solid box or base.

You will need some backgrounds to isolate the plants you are photographing, and some reflectors to fill in the shadows. If you make these from stiff cardboard and mount them on sharpened metal rods they will support themselves, and will also be firm enough to act as wind breaks. Wind will be a problem because it is necessary for everything to be still for successful plant pictures.

The depth of field with any close-up attachment is very limited so you need to use small apertures to compensate. Unless you use flash this will mean long exposures, which means the plant and camera must not move. Depth of field applies $\frac{1}{3}$ in front of the subject and $\frac{2}{3}$ behind, so you might angle your camera to maximize it.

The light on a bright but overcast day will be best; if it is a little blue use a skylight filter. Blue flowers are very difficult to photograph naturally.

To get perfect prints your exposure must be very accurate but it will help the processor to match the colour perfectly if you attach a colour sample to your print order.

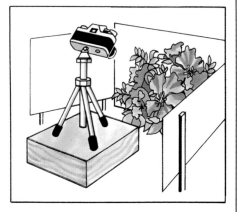

Technique
Small cards mounted to rods will act as backgrounds, reflectors and a wind break for garden close-ups.

Depth of field
Depth of field falls $\frac{1}{3}$ in front and $\frac{2}{3}$ behind your point of focus. The depth-of-field scale on your camera will help you utilize this.

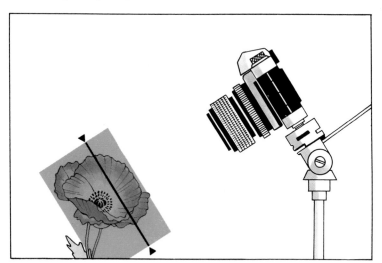

Warm evening light gives added colour to this display of Iceland Poppies.

STAMP AND COIN CLOSE-UPS

To photograph stamps you need to make the lighting as even and shadow-free as possible to ensure accurate colour representation. To do this you will need two light sources of equal power, either flash units or special photographic lightbulbs in reflectors. The latter will be easier to use because you can see the light to position it, but make sure you use the correct film for that type of light. Position the lights opposite each other about 4 feet away from the stamps at an angle of 45°. You will find it easy to set up the lights if you stand a pencil in the intended position of the stamp. If the two shadows of the pencil line up, are of the same length and the same densuty, your lights will be balanced.

With this lighting you can place the stamp album under a heavy sheet of glass to keep it flat without the lights reflecting but you may pick up a reflection of the camera, so fit a piece of black card with a hole cut in the centre over the lens. The camera must be parallel to the stamp, so you may find it easier to use a tripod with an arm.

With coins and medals you need the opposite form of lighting: the copy lighting above will not show up the delicate relief of the design. For this you need a single light at an angle of 15° to the coin; a small card reflector placed on the opposite side will fill in any heavy shadows. If the coin is highly polished it will pick up your reflection; get a sheet of grey or white card about 30cm × 18cm and cut a hole in the middle for the lens to fit through: fitting the lens hood will then hold the card in place and keep the low light out of the lens. If you use black velvet as a background you can make a double exposure to show both sides of a coin, making sure to position the coin carefully in each half of the picture.

Stamps and copying
Two evenly spaced lights at 45° to the subject give flat, even lighting for photographing stamps and flat objects.

Coins
To bring out the relief on this coin a single light was used with a small reflector to fill in the shadows.

MODEL CLOSE-UPS

Table-top photographs of models are one of the more challenging aspects of close-up. With the others you are using your camera as a scientific tool; with table-top you have a chance to be really creative. The way you build your setting, place the models, and light the scene are all crucial to your success. A macro lens giving $\frac{1}{2}$ size magnification or a set of extension rings will be the best close-up accessories to use.

The success of your setting depends on two things: the 'ground' detail and the background. Make sure that your 'ground' is wide enough for your lens's coverage; if you are using a high viewpoint, perspective might give you problems at the back. The narrow depth of field with close-up may leave some of the picture out of focus, so don't put too much detail where it is not required. A simulated sky background – blue paper with clouds added with spray-paint – requires careful lighting, usually wide and flat. Back projection can give you more realistic backgrounds (*see* p. 49).

Try to place your models as credibly as possible; imagine where a camera might be for the real thing. Flying planes should be supported on a stiff rod coming through the background so that the model shields it from the camera. Sometimes you can add extra effects to increase realism. If you want smoke in railway or battle scenes, fix thin plastic tubing out of sight of the camera and gently blow cigarette smoke through it; this will be more effective when you are using flash than with other types of lighting. For added realism in battle pictures use a slow shutter speed; this will give you camera-shake. Robert Capa, the famous war photographer, said that, 'If your pictures are too sharp you aren't close enough' – and a slightly blurred picture can look very authentic.

Except with science fiction settings your lighting should duplicate daylight. Don't forget that the sun's angle changes in different parts of the (simulated) world and that the colour of daylight changes through the day: dawn light is very blue and evening light is warm. Bounced light will give you the impression of a bright hazy day, direct light a desert sun.

Backgrounds
To represent clouds, cotton wool was stuck to a board and allowed to go out of focus in this picture of a model fighter. Backgrounds are very important for good pictures of models.

Focusing
Depth of field is so narrow in close-up photography that you must focus very carefully on the main subject. With this WW2 diorama the camera was focused on the eyes.

VALUABLES

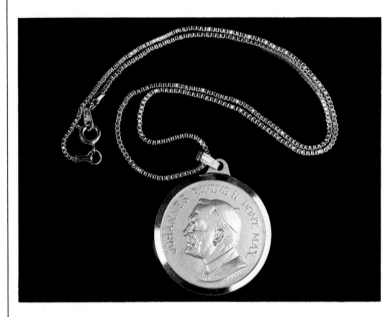

Jewellery
Black velvet is the ideal background for photographing jewellery.

Glass
Two evenly spaced lights at 45° to the picture give an even light without reflections for copying paintings behind glass.

You should always seek the advice of the crime prevention officer at your local police station or from your insurance company on the best ways to make your home secure against thieves, but even the most elaborate security arrangements are sometimes thwarted. In the event of theft it is far easier for the police to trace missing goods if there is a photographic record of them.

The more sophisticated cameras will give better results, but whatever camera you have you should take some pictures; with the simplest cameras you must be aware of the limitations of using close-up and flash. As well as a close-up accessory you will need a good tripod. If you choose your day you should be able to utilize natural light, but it might mean long exposures. Daylight will give more accurate results than flash, but you will have to use reflectors to lighten the shadows. On very sunny days tape tracing paper over a window to diffuse the light.

Start by doing a wall-by-wall photographic inventory of each room in your house. Put your camera on the tripod in the middle of the room and photograph each wall, including the furniture in front of it. This will form a useful record of all your possessions in the event of any insurance claim.

For more valuable pieces take individual photographs: furniture and carpets will be the largest items. Furniture is better photographed against a plain background; if it is too large to move, get some help to support a plain blanket behind it. As well as the main shot you should photograph any special details: close-ups of any carving could be invaluable. Without special equipment and lighting it will be almost impossible to get a good picture of a carpet so just get as high as

possible above it. Try to get it all in your main shot and again take
detail shots to accompany it.

To photograph a painting, especially if it is behind glass, you
should use the same principles as for photographing stamps (*see*
p. 80). Include the frame: sometimes it can be worth more than the
picture. When you get your prints back make notes on the back
giving the size, the artist's name and any other relevant information.

It will be useful to show the size of smaller objects and the way to
do this is to include a ruler in your picture. A plastic ruler will do but,
to make it easily readable, fill in the alternate inches with coloured
tape.

For small items like porcelain and jewellery you can create a little
studio by a bright window. Again, cover the window with tracing
paper to diffuse the light, fix up a sheet of coloured card at 90° to the
window and use a small white card in a block of wood as a reflector.
Jewellery will show up best on black velvet laid over the card.

Be careful when photographing silver. Any material with shiny
curved surfaces will pick up reflections over a wide area, resulting in
loss of detail. Place it in front of a dark background with a white
sheet draped behind the camera to counteract the reflections. With
all hall-marked pieces you should either take an extreme close-up
photograph or make a drawing of the marks on the back of your prints.
To write on the back of a print you have to use a pen designed to write
on any surface; modern prints are made on plasticised paper.

File the prints away with your insurance papers when you have
made full notes on the backs, but pass the negatives to someone else
for safe keeping: this way you will have a record whatever happens.

Notes
Make full notes on the back of the
pictures about size and distinguishing
marks.

URBAN LANDSCAPE

Most people live in urban as opposed to rural areas yet somehow landscape photography is thought of as only being about hills and valleys, rivers and streams. Nevertheless, the views you get in cities and towns can have as much character as any to be found in the countryside – it all depends on the way you look at things. Familiarity has probably closed your eyes to the views around you in your home town. Also, because of the preoccupations of work and day-to-day living, people seldom look above ground-level facades. Sadly, many beautiful old buildings have their ground floors hidden by pre-fabricated laminated shop fronts; their true glory begins at the first floor. Still, urban landscape is not just about big buildings; because

David Bailey set out to document London's riverside before it is all changed.

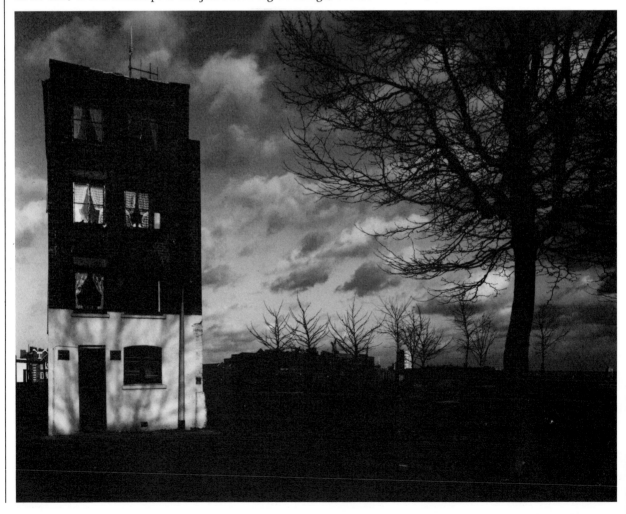

urban landscape is man-made there is interesting detail in abundance. Small items such as letter boxes and front doors vie with fragments of classical architecture; boarded-up buildings with hoardings covered with torn posters give witness to decay.

But it is not just the shapes and patterns of the architecture of towns and cities that waits to be discovered. The moods and the weather of urban landscape change as fast as any in the country. A sudden rain storm can turn a city centre into a blaze of reflections as its neon lights are mirrored in puddles. The advantage of this sort of subject is that the raw material is around you: if you care to look there are pictures everywhere.

The best way to get started is to set yourself a project. The range of subjects is vast, everything from recording an overall view of the town to the changing look of a particular structure.

The first thing to look for is light. The cool fresh colour of the light can add a new dimension to a familiar sight. At different times of day

Careful composition and exposure give a sculptural quality to this riverside fencing.

the shadows change the whole look of a place. In the early morning the low sun casts long shadows and illuminates only the tallest buildings. As the day progresses everything changes. The harsh light at noon forms canyons in commercial districts. Then the contrast between the bright and dark areas of your picture will be difficult to handle satisfactorily: you must either meter for the shadows or for the sunshine. Each will give a different effect. If you hold detail in the shadows the bright areas will 'burn out' and give a feeling of great contrast in temperature. If you expose for the bright areas the shadows will go so black that you can add a feeling of mystery to an ordinary view.

As the day draws to an end glass walls turn gold in the setting sun and dusk turns tall buildings to silhouettes. If you wait for the lights

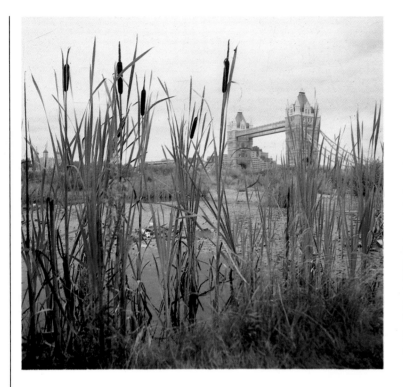

in offices to come on you may still catch the deep blues and purples of the setting sky. At night the urban landscape comes alive in a way that the countryside never could. The dark shadowy canyons of the day become rivers of moving car lights. This is the time to try some special effects. A zoomed shot of the city skyline at night becomes a beautiful abstract that the eye would never see.

The seasons and the weather make their contributions to the urban face changes. The way the seasons change can be encapsulated by a single tree in a shopping precinct; it can tell you as much about the town dweller's life as a forest. Boulevards of cool summer shade become spidery and menacing in the winter as the first falls of snow reduce the view to a natural black and white.

With so much variety of subject and viewpoint there is no right or wrong equipment. The standard camera and lens may be a little restricting: within the urban landscape it is not wide enough to open up the view, nor long enough to concentrate on individual details.

The perspective distortion of a wide-angle lens can be used to enhance the height of buildings: the ground will look twice as far away when you look down from a high viewpoint with a wide-angle lens on your camera. A telephoto has the opposite effect and compresses the perspective, making streets seem shorter and buildings more closely crowded; it can be used to emphasize the claustrophobia of city living.

You can leave people out of your pictures if you wish, and an obvious time to go out and take pictures is at the weekend when many

Looking
The Tower of London and Tower Bridge are an unlikely setting for reeds and water lilies.

Detail
The evening sun vividly highlights this stained glass porch.

Colour
Murals and grafitti can provide a splash of colour in the drabest surroundings.

Humour
A photograph pasted over a window gives a *tromp l'oeil* effect to this French photographer's shop.

Atmosphere
The out-of-focus tricolour leaves no doubt as to the location of this beautiful wrought-iron gate.

city streets are deserted. But you can 'lose' the people on a weekday as well: if you use a very slow film you can get very long exposures by using a small aperture. You will have to mount your camera on a tripod for a long exposure, but it means that moving people will not record on the picture.

Towns are good places to use filters; by removing reflections a polarizing filter will allow you to look into shop windows as well as deepening the colours of the sky and automobiles. At night an X-screen will turn the city lights into a wonderland. Towns are good also for using a multi-image filter to produce beautiful, if un-recognizable, abstract patterns.

TELLING A STORY

With any situation or event to which you have taken your camera there are many different ways of photographing it. Normally you would simply take pictures of your own family in your own style, but you will be much more successful if you can break out of this and set out to tell a story with your photographs. This is particularly important if you intend to put together a slide show, but it will also give a new life to photograph albums. All you have to do is open your eyes to all the activities that make up the total. These can be roughly categorized into: broad or general; information; and detail. All are equally important to the telling of a story.

The broad or general shots set the scene. If you are visiting a cathedral city, you could take a picture some distance away, with the spire of the cathedral rising through the distance, with the added benefit of showing how the cathedral dominates the town. A holiday trip to a vineyard could be represented with a landscape picture showing the hills covered with vines.

Broad shots
These are used to set the scene of your story – in this case a wagon ride in the New Forest.

Information shots
These represent the main part of your story. In this picture the horses are brought into Lyndhurst from their pasture.

Detail pictures
The driver of the wagon was one of the local characters met on the day. A fast shutter speed was needed to compensate for the movement of the wagon.

The information pictures will make up the bulk of what you do. Don't just photograph your own family; there are things going on all around you that will help convey the atmosphere and activity to someone looking at the pictures later. In the cathedral town there will be quaint book and antique shops near the close; colourful tourists and their coaches; clergy and officials. In the vineyards there is the whole process of turning the grapes into wine.

The detail pictures add colour and interest, perhaps just photographs of 'insignificant' things like an old sign or the label on a bottle, but they will turn your picture story into something real. This is the way picture-magazine editors make up a story. Try to do the same with your photograph album.

Inertia
To tell a story successfully you may have to make a real effort. Getting off the slow-moving wagon and running ahead gave this picture of the whole party.

Permission
It is not always safe to wander around working areas, so it is a good idea to get permission first.

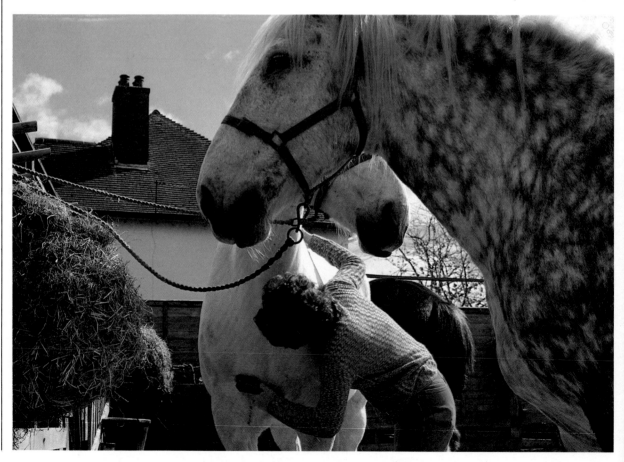

DISPLAYING YOUR PICTURES

ALBUMS

You can use your pictures in many ways to beautify your home. Albums can make an ever-changing display on a sideboard supported on a cookery book holder and simple block mounts can turn a useless corner into a charming record of your growing children.

Most film processors print your pictures as En-prints although this popular $5'' \times 3\frac{1}{2}''$ size is now being replaced by larger $7'' \times 5''$ prints. En-prints are ideal for albums but the larger sizes may need to be cut down. This is not a bad thing: different-sized pictures are the first step in making an exciting album.

The first thing you must do when your pictures come back is to write the subjects on the envelope. Then remove the prints and put the envelope away (*see* p. 98). *The processor should have packed your negatives safely and there is no need for you to touch them at all.*

Now edit your pictures. First remove any that are genuinely so bad as to be no use, then arrange the others in chronological order, removing any repeats. Don't throw these away because you can send them to relatives or friends, much cheaper than getting reprints.

Cut two L-shapes from black card to use as adjustable masks; these will help you to see if any picture can be improved by cropping. Place the L's over each other and alter the shape until you find a format you like. They are also invaluable in selecting pictures to be enlarged.

Use a sharp craft knife or scalpel and a steel ruler to crop the prints; unless the knife is sharp you will not get a good edge. Use a piece of thick cardboard to cut on and change it frequently, or the previous cuts will deflect the knife blade. Make sure that you cut the corners square.

Draw a full-size outline of the album page on a large sheet of white paper. When you have decided which pictures you want on each page you can plan your layout on this sheet. Work to a grid as they do with newspapers; your album pages will then seem much more designed. Draw the grid up using suitable size columns and try to crop your pictures to suit.

You do not need to confine yourself to photographs in the album; other bits and pieces like tickets, maps, postcards and even letters can add extra dimensions.

Write your captions on self-adhesive labels rather than straight into the album, in case you make any mistakes; you can use small pieces of notepaper for albums with adhesive pages.

You can often find old albums in junk shops that can be cleaned up and are more attractive than their modern counterparts. The Victorian type, where the pictures slid under a mask, are particularly beautiful. But it can be more fun to make your own. Any art shop will have a stock of stiff papers and cards, and many stationers have a binding service.

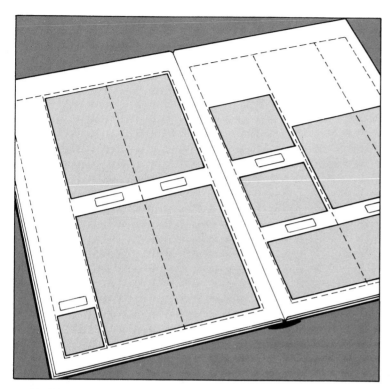

Album grid
Laying out your album on a grid, like a newspaper, will give you more interesting pages. Draw the grid up on plain paper to experiment with layouts.

Showing off your pictures
A nicely set out album can be displayed alongside framed pictures by using a cookery book stand.

FRAMING

There are two types of enlargements you can order – machine or hand. Machine enlargements are made automatically in the same way as your En-prints. This will limit your choice of which part of the picture you want enlarged, and the colours may not be truly accurate. Hand enlargements are much more expensive but you can expect greatly improved results.

There is unexpected pleasure in having enlargements of your own pictures displayed on the wall and if you have made the enlargement yourself, so much the better.

For a formal display it is better to use frames or mounts of the same size; many mass market furnishers offer ranges of frames in wood or metal suitable for walls or shelves.

Before you put up the frames you should plan the layout: make a drawing of the area where they will be, trying out different ideas. Once the frames are up you should change the pictures from time to time to keep the display interesting. The range of free-standing frames is vast; as well as the more traditional metal or wood they are also

Displays
A selection of different frames can add interest to a display of family pictures.

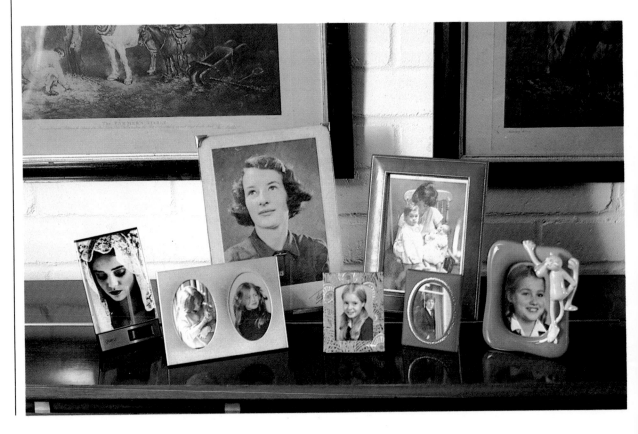

made in ceramic and mirror. A display will be more attractive if you make it up of different types of frame; you may be surprised how well antique and modern frames can blend together.

Any picture will look better in a frame if you use a matt or window surround to set it off. There is a large range available in good art shops with either square, rectangular or oval windows; they also come in a range of colours. Choose colours carefully; matts that pick up colours in the photograph are good, and black and brown will enhance most colour pictures.

It is easy to make your own matts. When you have used your cardboard L's to decide on the picture-size, mark this out on the card using a soft pencil. Do not trim the picture. Cut out the shape using a very sharp craft knife and a steel rule, being careful not to cut too far at the corners. Mount the picture on another piece of card, larger than the window, and tape it into place. If you are artistic you can decorate the matt to suit the picture.

You may feel that it is more fun to make an informal display. This works particularly well in odd-shaped corners and up staircases. Block mounts are better for this: with these you mount the picture flush to a piece of wood or board. Self-adhesive block mounts are available for wall-mounting, or free-standing, or you can make your own. The cheapest way is to cut thin block board to the required size and simply glue the picture to it. You can buy sheets of self-adhesive paper faced

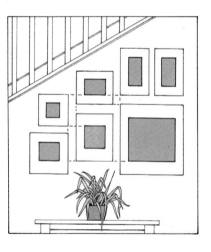

Wall displays
Different size pictures can make a beautiful display in odd-shaped spaces, such as the side of a staircase.

with polystyrene that is easily cut with a craft knife to any size. Where wooden mounts need a substantial means of support the polystyrene is so light that it can be fixed with discs of Velcro.

The secret is to vary the size. This is not only visually more attractive but enables you fully to use the space. You can devote an informal display to a single theme, say, the children. The most informal display of all is a pin-board with the pictures fixed on by drawing pins, but the pin holes do spoil the pictures. Metallized boards using tiny magnets are available so that pictures can be easily changed without spoiling them. These are ideal for just displaying snapshots.

Magnetic boards
You can create a changing display of pictures and other mementos using special magnetic display boards.

EXTRA USES

As well as displaying your pictures in an album or on the walls you can put them to use as Christmas cards and holiday postcards, as well as turning them into unusual gifts.

At Christmas time many photographic processors will offer special folders to use as cards: you simply tuck in a picture of the family or whatever you choose. Some processors will print a Christmas message on the photograph itself.

It is nicer, though, to use a plain card with a printed message inside and simply stick a suitable photograph on the front. For Christmas scenes it is a good idea to take pictures one Christmas for use as cards the next. If you want to include the family in these you should leave taking the picture as late as possible; children grow so fast.

You can be much more adventurous if you use montage techniques or have got a darkroom. A combination print will produce a very personal' card.

1. Cut a mask representing a sprig of holly with a leaf for each member of the family. Draw it out first on thin opaque card and use a sharp craft knife to cut out the leaves.

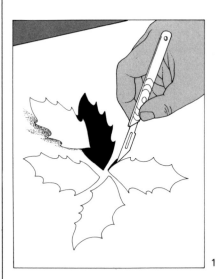

1

3

2. Choose individual pictures of the members of the family against a dark background, either in colour or black and white. The idea is to make each person into a leaf and it will be easier if you don't have to move the enlarger. Work out the exposures for each in the normal way.

3. Cover the other 'leaves' and make your print. Use the red safe filter on the enlarger when you change negatives and need to line up the different faces. If you need to focus each time you will have to remove your paper; it is easier to put it back the correct way if you make a small mark on it to indicate the top, and on the mask.

4. Repeat with the other 'leaves' and then process.

The photocard can be used for announcements of the birth of a new baby using a picture of mother and child. Use an ordinary print and write the relevant information on the back (you will need a special pen because of the paper's plastic base). Photographic change of address cards also help your friends find the new house.

If you do your own printing you can use transfer lettering to make up your own mask to include a message on a picture.

1. Make up the mask on clear plastic sheet. Stick black paper where the picture will come.

2. Make the print exposure normally but leaving a large white border.
3. Remove the negative and place the mask over the exposed paper. Switch on the enlarger for 2–3 seconds. The lettering will be white on a black border.

There are many ways that you can turn a photograph into a gift. The easiest is to simply frame an attractive picture using a hand-made matt, but it is not difficult to make a frame yourself using dressmaking scraps.

1. Cut the basic frame shape out of stiff cardboard.
2. Place the cardboard face down on the material and cut out the shape with a sharp craft knife, allowing ½" so that it comes round the back of the cardboard. Push four paper fasteners through the card-board from the front.
3. Glue the material into place.
4. Mount the photograph. Cover the back with a thin card; this will be held in place by the paper fasteners. You can then fix a loop or support to the back of this card.

There are several commercially available gifts to be made from your pictures. You can get a real wooden jigsaw cut with a picture on one or both sides, available in several sizes. You can also get individual pictures cold-glazed onto plates for decoration or use.

STORAGE

You spend a lot of time and effort in taking pictures and properly looked after your negatives and prints will give you years of pleasure. But too often negatives are unnecessarily handled, rendering them useless for reprints or enlargements, and prints are positioned where they will fade in a short time.

The surface of a photographic negative is extremely delicate and must be protected. A chance finger-mark or scratch will irreversibly spoil the results from that negative. Unless you process your own negatives you should never need to handle them: mark your envelope with the details of which negatives are inside and store it in a cool dry place. If you want to order a reprint you should take the whole envelope and the print in question to the shop; let them locate the correct negative because they have been trained to handle them properly.

If you process your own films you must handle the negatives with care: let them dry in a dust-free environment and resist the temptation to look at them before they are completely dry. You can easily tell when they are dry – the wet film curls and doesn't become truly flat until it is touch-dry. Handling them by the edge, cut them into lengths and store in a purpose-made negative sleeve. It is safer to use cotton gloves when handling your films. File away your contact sheets with the negatives for easy reference. Treat your negatives with the same care whenever you use them, handling them by the edge and keeping them dust free. Treatment with an anti-static gun or cloth will help.

The dyes of colour prints are not stable in long exposures to bright sunlight and will fade, so you should not display pictures where this will happen. Pick a shaded area for showing your pictures and they will last much longer. The dyes used in printing from colour transparencies are slightly more stable but still should not be displayed in bright light.

DEVELOPING AND PRINTING

YOUR OWN DARKROOM

Because the undeveloped film is still sensitive to light, part of the processing must be carried out in total darkness. The time spent in darkness varies from a few minutes when developing a film to long periods when making a colour print. The remainder of the processing can often be carried out in normal light by using special light-tight equipment.

If you simply want to *develop* a film you don't need a darkroom. It is possible to load it into the special tank using a changing bag, a special dark bag with two elasticated arm holes. As an alternative for loading the film in the tank you can use a small cupboard, as long as it is completely dark.

Printing needs more space: you require an enlarger as well as dishes of chemicals, all of which may need to be used in the dark. The most comfortable way to do this is to create a darkroom. The ideal is a permanent set-up in an attic or basement, but if you cannot devote space exclusively to your photography you can temporarily convert another room.

A darkroom has to be completely light-tight, so select a room that can easily be blacked out; small draught-free windows and a solid door will help. Avoid rooms with carpet: it is vital for high quality results that your darkroom be dust-free. There is also the risk of spilled chemicals.

The bathroom is popular for a temporary darkroom but it is not really suitable: you need electricity for making a print, which should not be available in a bathroom. You could use leads to bring it in, but this makes it more difficult to achieve total darkness, and is not safe. Moreover other members of the family may need to use the bathroom throughout the day.

The kitchen may be harder to make light-tight but it will usually be more suitable. In an ideal situation you need at least two power points, and hot and cold running water. You will have to take precautions against contaminating food with photographic chemicals. Fit a bolt to the door to prevent it being opened accidentally when you are working.

To black-out windows, a fitted frame covered with plywood is ideal; stick draught-excluder strip around the edges for a tight fit: you can fix clips to hold it firmly against the window frame. A cheaper solution is to use opaque black plastic taped over windows: you can buy special black-out plastic that adheres to glass.

If possible you should separate your darkroom into a *dry area* and a *wet area*. The dry area is where you will do your printing with your enlarger and photographic papers; the wet area is for developing films and prints. This way you reduce the risk of chemicals splashing and contaminating your pictures.

A lot of processing can be done in ordinary light and since both colour and black and white prints must be evaluated under white light, a convenient and safe switch for the main light is invaluable.

One of the secrets of successful home processing is to make sure

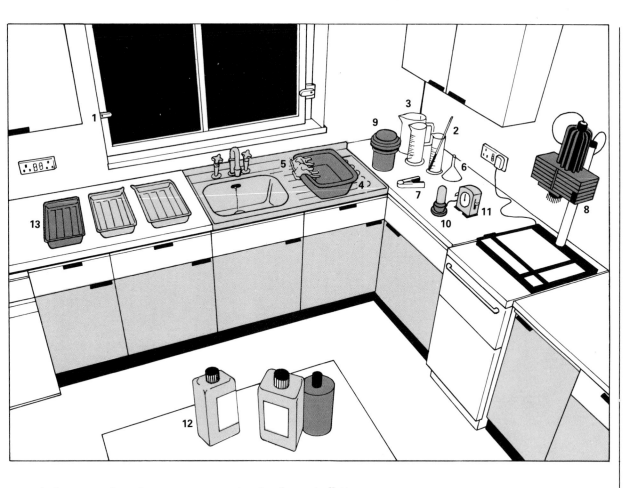

your darkroom and equipment are scrupulously clean at all times. Wash up your measures and other equipment as you go along; if you are in any doubt about a measure being clean you should wash it before you next use it: chemical contamination could ruin your film.

Checking if it is dark

Before you use your darkroom you must check that it really is dark. When it is fully blacked-out place a small sheet of photographic paper face up on the table. Lay some small coins on the paper and leave for about 15 minutes, then develop the sheet. If you can see the outline of the coins on the sheet your darkroom lets in light. Trace the leak, rectify it and test again. If you are printing your own black and white pictures, you should also check by the same method that your orange safelight is not too bright or too close to the worktop.

1 Black-out
2 Thermometer
3 Measures
4 Bowl
5 Rubber gloves
6 Funnel
7 Film wiper
8 Enlarger
9 Developing tank
10 Safe light
11 Timer
12 Chemical containers
13 Dishes

HOW FILM WORKS

Developing and printing your own pictures is not difficult but it will help if you understand how light affects film and the principles of developing and printing both black and white and colour pictures.

1 Light appears to be white,

2 but it is actually made up of red, blue and green light. These are called *primary* colours.

3 Two primary colours form a *secondary* colour. Red and blue form magenta. Green, the other primary colour, is its *complementary* colour.

4 Blue and green make cyan which has red as its complementary colour.

5 Most strangely red and green *light* make yellow. Blue is the complementary colour of yellow.

6 Secondary colours contain no light from their complementary colour.

7 Black and white film is made up of silver salts sensitive to white light. During an exposure those struck by light become activated.

8 Developer turns activated salts into grains of silver. The more light affects the film, the more silver forms on the negative.

9 The fixer dissolves any remaining silver salts and the negative is now safe for light.

10 Black and white paper is sensitive only to blue light so you can have special red or orange safelights in a darkroom.

11 Black and white paper is similar to film, with light sensitive silver salts on a white backing, and works the same way.

12 Colour negative film works on the same principles as black and white film but has three layers of silver salts sensitive to light.

13 Each layer is sensitive to one of the primary colours. One is sensitive to red light; one to green light; and one to blue light.

14 To form a negative, activated salts in each layer take on their complementary colour when developed. Those in the red layer turn cyan,

15 those in the blue layer turn yellow,

16 and those in the green layer turn magenta.

17 The colour negative also has an overall orange-coloured mask to compensate for imperfections in the dyes.

18 Colour paper is sensitive to nearly all light, so you should work in total darkness.

19 The negative acts like a filter with each secondary colour only allowing light of its own primaries to pass.

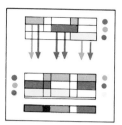

20 The colour paper is also made up of three layers, each sensitive to a primary colour and being developed to its complementary.

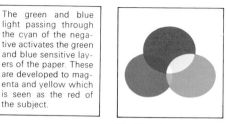

The green and blue light passing through the cyan of the negative activates the green and blue sensitive layers of the paper. These are developed to magenta and yellow which is seen as the red of the subject.

21 After developing and bleach fixing the print you get a positive image.

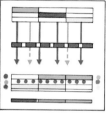

22 If the colour of a print is inaccurate you use colour filters to alter the colour of the light from the enlarger.

eg.
If a print has too much magenta you introduce a magenta filter. This will block some of the green light reaching the green-sensitive layer which is developed to magenta.

23 Colour transparency film also has three layers sensitive to primary colours.

24 One is sensitive to red light; one to green; one to blue.

25 When the exposed film is put into the first developer, all the grains activated by light are developed to silver – the red layer,

26 the blue layer,

27 and the green layer.

28 The remaining sensitized grains in each layer are then activated chemically (E6) or by light (Agfachrome).

29 When the colour developer is added the newly activated grains on the red layer are developed to cyan,

30 those in the blue layer go yellow,

31 and those in the green layer go magenta.

32 The film is now a positive image comprising the three layers and the dark silver negative image. Bleach fix removes this negative image,

33 leaving a positive image.

34 When projected, each secondary colour layer blocks its complementary colour. Any cyan blocks red light; yellow blocks

blue light; magenta blocks green light. So light passing through any single layer will be of that colour and through any two layers will be the colour of the common primary.

WHAT YOU NEED

The equipment you need to develop and print your pictures is available separately or as a complete kit. The kit shown below for developing a film includes some items that are also needed when making a print.

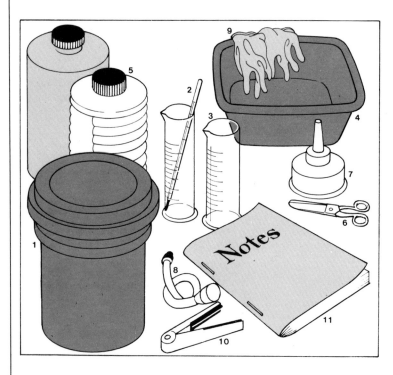

1 Developing tank
2 Thermometer
3 Measures
4 Bowl
5 Chemical containers
6 Scissors
7 Funnel
8 Wash hose
9 Rubber gloves
10 Film wiper
11 Notebook

To develop any film

Developing tank
The film is threaded on to a spiral which is placed in the tank. Once the lid is fitted the tank is light-tight. Tanks are available in many sizes to take up to 6 films at once, but the most suitable is the 1–2 film size.

Thermometer
The temperature of all photographic processes must be carefully controlled. A photographic thermometer is easy to read and covers the required temperature range.

Measures
A range of plastic measures for the accurate mixing and use of the chemicals.

Bowl
To keep your chemicals at the correct temperature it helps to put the measures in a bowl of warm water.

Containers
Many photographic chemicals are re-usable but must be stored properly. Dark plastic bottles that can be concertinaed to exclude air will be best.

Scissors
Because you will be working in darkness it is safer to use blunt-ended ones.

Funnel
This will be useful for pouring chemicals.

Wash hose
You must thoroughly wash your film after processing. It is easier to use a purpose-made hose that fits in the top of your developing tank.

Rubber gloves
All chemicals must be treated with care. Rubber gloves will protect your hands.

Film wiper
You need to wipe any surface water off a film before it dries. Nothing is perfect for this, but a purpose-made rubber wipe is as good as anything.

Notebook
Keep a note of everything you do in your darkroom. This will be useful for future reference and will help you trace any mistakes.

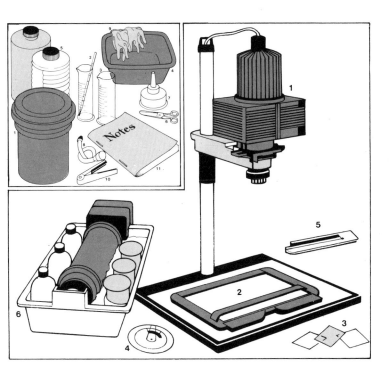

1 Enlarger
2 Easel
3 Filters
4 Filter guide
5 Paper squeegee
6 Processing system

Extra equipment for colour prints

Enlarger
An enlarger does the reverse of your camera and projects your negative or transparency on to a sheet of sensitive paper. Buy one solidly made with a firm base and a head that moves smoothly. A good quality lens for an enlarger is very important. This is not always supplied with the enlarger but a large range is available at reasonable prices. Check that your enlarger gives even illumination over the print sizes you want to do.

Sheet of glass
This flattens negatives when contact printing.

Easel
This holds the paper flat under the enlarger. It can either be for a fixed size of paper or adjustable to a range of sizes.

Filters
To achieve correct colours, add filters to the enlarger's light-source. Special colour enlargers have these filters built into a colour-head. The alternative is a set of colour filters that fit in a small drawer in the enlarger. For successful colour printing make sure an ultra-violet (u/v) filter is included. A colour enlarger will also make black and white prints.

Filter guide
It seems complicated to select the correct filters. A guide shows the effect different filters would have on a standard negative or transparency.

Paper squeegee
Wipe surface water off paper before it dries.

Processing system
Colour prints can be processed in dishes but it is easier to process them in a light-tight system: once the lid is sealed you can turn the room lights on. They also use less chemicals; the basic drum system is rolled backwards and forwards by hand on a flat surface to agitate these. More sophisticated types have motors to rotate the drum and a temperature-controlled water-bath to keep it at the recommended temperature. There is space for bottles to keep the chemicals at the same temperature and you have the added advantage of processing films in the drum. A simpler system suitable only for prints is the manual or powered orbital tray.

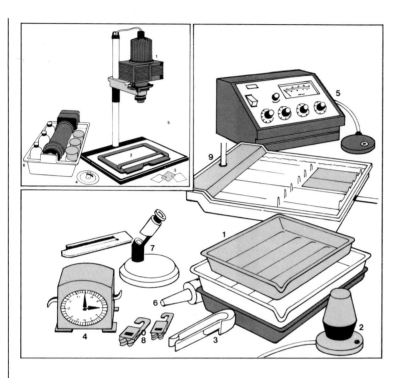

1 Dishes
2 Safe light
3 Print tongs
4 Timer
5 Colour analyser
6 Water filter
7 Focus finder
8 Film clips
9 Print washer

Extra equipment needed for black and white prints

Dishes
You will need three dishes a size larger than the paper you use. These are for the developer, stop bath and fixer.

Safelight
Black and white printing does not have to be done in total darkness; a *special* red light or bulb will give you adequate working light. It should be positioned about 5 feet from your working area.

Print tongs
Use these or rubber gloves to handle the print in the chemicals. Do not use your bare hands.

Extras
Some equipment is not vital to developing and printing but can make darkroom work a lot easier.

Timer
Whilst it is possible to use a watch for timing all photographic processes, a timer will be easier to read and use. For enlarging, which takes relatively short times, you need an easily-read second-hand; film- and print-developing is normally timed in minutes. Some timers can be connected to the enlarger for automatic timing.

Colour analyser
If you are doing a lot of colour printing an analyser will give you the correct filter combinations for individual negatives. They are rather expensive.

Water filter
In some areas water contains small particles of sediment that can spoil a film. A simple water filter will remove these.

Focus finder
You can focus an enlarger by eye but a focusing aid concentrates on a tiny section of the negative for very accurate results.

Film clips
You can use clothes pegs to secure a film for drying but purpose-made clips are safer.

Print washer
Prints must be thoroughly washed to preserve them. A specially-designed washer will be more effective.

LOADING A SPIRAL

The most difficult part of developing a film is loading the spiral, which must be done in total darkness; it is worthwhile practising with an old film until you are confident. Use a hair dryer to make sure the spiral is completely dry before trying to load it: a damp spiral will jam.

If your film does jam when loading the spiral *do not force it*. Stay calm, remove the film gently from the spiral and try again. If it still sticks put the spiral and film into a bucket of water at approximately the process temperature, then it will slide on easily. Keep a bucket full of water at the right temperature on hand whenever you are loading a spiral, because this emergency measure must be done in total darkness.

Before starting set out all your equipment where you can find it in the dark and do a dummy run.

Open the film cassette. Some brands will open by squeezing the sides and pulling off the lid; others have crimped tops that are difficult to open, but a bottle-opener will help.

Cut the leader off the film. Try not to cut through the perforations.

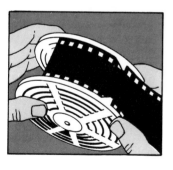

Position the guides on either side of the spiral opposite each other, then slot the film in so that the curve follows the curve of the spiral.

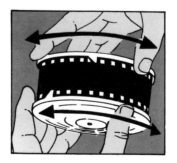

Rotate the spiral with your thumbs acting as guides until all the film is taken in, then cut it off the core. Place the spiral on the centre and fix the collar. Put it in the tank and fit the lid.

Agitation

Try to be consistent with your agitation. Make sure the cap of the tank is firmly in place, then invert and return it the recommended number of times.

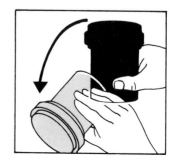

DEVELOPING COLOUR PRINT FILM

1

2

7

8

In total darkness
1 Load the film in the tank.

In light

2 Mix the chemicals and bring them to temperature in the bowl. Make sure you mix up enough for the film you are going to process.

3 Preheat the film using warm water and place the tank in the bowl. Drain the tank. (1 minute at 40°C)

4 Pour in the developer and start your clock. Tap to dislodge any air bubbles. Agitate twice every 15 seconds. Ten seconds before time drain and preserve the chemicals. ($3\frac{1}{4}$ minutes at 38°C)

5 Rinse in 3 changes of water or use the stop bath. (30 seconds at 38°C)

6 Pour in the bleach fix (called Blix). Agitate for 1 minute, then for 5 seconds every 15 seconds. Pour out and store for re-use. (4 minutes at 35–40°C) *This part of the process may alter for different film types.*

7 Wash in running water. (5 minutes at 30–35°C)

8 Add wetting agent to the water, hang the film up in a dust-free place and wipe it.

3 – 6

This information applies to process C-41 only

The process is marked on the film cassette. Process C-41 is suitable for Kodacolor II and 400; Fujicolor II and 400; Boots Colourprint II and 400; Smiths Colourprint; Agfacolor CNS400

To give some idea of how long a process might take, times and temperatures have been given. They are for Photocolor II chemicals. Other makes may have different times and temperatures. The information given is accurate at the time of going to press but improvements are continually being made and you must check the manufacturers' instructions before commencing.

THE TEMPERATURE OF CHEMICALS IS IMPORTANT IN ALL PROCESSING

DEVELOPING COLOUR TRANSPARENCY FILM

1

2

3 – 9

10

11

In total darkness
1 Load the film in the tank.

In light
2 Mix chemicals and bring them to temperature in the bowl. Make sure you have mixed sufficient chemicals for the films you intend to process.

3 Preheat the film using warm water and place the tank in the bowl. Drain the tank. (1 minute at 43°C)

4 Pour in first developer and start your clock. Tap to dislodge any air bubbles. Agitate twice every 15 seconds. Ten seconds before time drain and preserve the chemicals. (6½ minutes at 38°C)

5 Wash in several changes of water. (2 minutes at 34–42°C)

6 Pour in the reversal bath. Agitate for 10 seconds. Drain and preserve chemicals. *Do not wash after this stage.* (2 minutes at 34–42°C)

7 Pour in colour developer. Agitate for 15 seconds and then for 5 seconds every 15 seconds. Drain and preserve chemicals. (6 minutes at 38°C)

8 Rinse in several changes of water. (1 minute at 34–42°C)

9 Pour in the bleach fix. Agitate for 1 minute continuously and then twice every 30 seconds. Pour out and preserve. (8 minutes at 34–42°C)

10 Wash in running water or with frequent changes. (4 minutes at 34–42°C)

11 Add wetting agent to the water, hang the film up in a dust-free place and wipe.

Small variations in temperature can be allowed for in processing times. See the individual instructions.

This information applies to process E-6 only

The process is marked on the film cassette. Process E-6 is suitable for Ektachrome 64, 200 and 400; Fujichrome 100 and 400; Boots Colourslide 100, 400 and 3M 640T.

Process times and temperatures have been given for Photocolor Chrome-Six chemicals only. The information given is accurate at the time of going to press but always check the manufacturers' instructions before proceeding.

THE TEMPERATURE OF CHEMICALS IS IMPORTANT IN ALL PROCESSING

THEORY OF COLOUR PRINTING

Colour printing must normally be done in total darkness. There are certain 'safelights' for some colour work but they are so dim that you will be better to get used to working in the dark.

1

Making a print

In light:

1. Make up your chemicals and then place the negative in the enlarger with the shiny side up.

2

3

4

5

In darkness:

2. Frame up and focus the picture on your easel. Set the filters. There will be an initial recommendation on the paper box. Your contact sheet (*see* below) will help you with your initial filtration.

3. Take a sheet of paper and make an exposure. A test strip (*see* below) will help you decide the exposure.

4. Process your print according to its type (*see* p. 112) and, when dry, compare it with your filter guide to set your final filtration.

The test strip.

Making a test strip

5. A test strip is a way of checking both exposure times and colour balance. By using a cardboard mask you make 4 progressive exposures on a half-sheet of photographic paper. Expose the full sheet for 5 seconds. Cover a quarter and expose for another 5 seconds. Cover half the sheet and expose for 10 seconds. Finally cover three-quarters and expose for 20 seconds. Each quarter of the strip has now had double the exposure. The times will give strips exposed for 5, 10, 20 and 40 seconds. After processing *and drying* the correct exposure can be assessed. When you have corrected the exposure you can use the same method to experiment with filtration, but exposing each test separately.

The contact sheet.

Making a contact sheet

A contact sheet is a print of all the negatives on a film, with each image the same size as the negative. Although small, these pictures will help you choose which ones to print and how to crop them. It will also

help you work out the starting filters for the proper prints. You then file the contact sheet away with your negatives for reference. You can also make a contact sheet of transparencies.

1. You need a sheet of colour paper of at least 10" × 8" size. Set your enlarger high enough for the light to cover the paper package. Set the filters recommended for the paper and prepare as if to make a print.

In darkness:

2. Place the paper face up on the base-board and arrange the negatives, shiny side up, on it. Put a sheet of glass on top to flatten the negatives.
3. Make a test strip as above.
4. Process, depending on the type of paper, and dry.
5. Use the test strip to assess exposure, then make your exposure. File the details, because similar films will use the same exposure.

Using filters

Since all three secondary colours together make black, two filters will balance the colours. With colour negative printing you add the colour you wish to reduce in your print, e.g. if the print is too magenta, increase the magenta filtration.

Colour Cast	add these filters	or subtract these
cyan	cyan	yellow + magenta
yellow	yellow	cyan + magenta
magenta	magenta	cyan + yellow
red	yellow + magenta	cyan
green	cyan + yellow	magenta
blue	cyan + magenta	yellow

If the print is too light it needs more exposure; if too dark, less.

With transparencies you work more logically: if the print is too magenta you cut back on the magenta filtration.

Colour Cast	add these filters	or subtract these
cyan	magenta + yellow	cyan
yellow	magenta + cyan	yellow
magenta	cyan + yellow	magenta
red	cyan	yellow + magenta
green	magenta	cyan + yellow
blue	yellow	cyan + magenta

The exposure is not so logical: because it is a reversal material, increase exposure to lighten and *vice versa*.

The packet your paper comes in will have a recommendation for a starting filtration. Do not adjust filtration until the print is dry. Keep notes of the filters you used for each final print, for reprinting the same or a similar negative. Be sure to note all the other information, such as enlarger height, aperture and paper base filtration.

The guide, right, will help you decide which filtrations to correct.

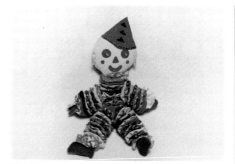
The final print.

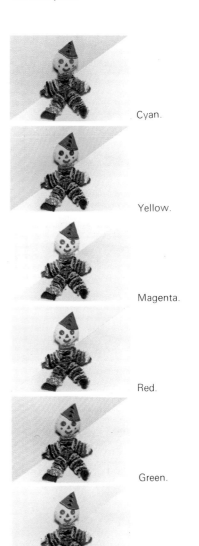
Cyan.

Yellow.

Magenta.

Red.

Green.

Blue.

PRINTING FROM COLOUR NEGATIVES

This information applies to processing Photocolor RC, Ektacolor 74 and Agfacolor Type 5 paper only

To give some idea of how long a process might take times and temperatures have been given. The times and temperatures are for Photocolor II chemicals. Other makes may have different times and temperatures. The information given is accurate at the time of going to press but improvements are continually being made and you must check the manufacturers' instructions before proceeding.

THE TEMPERATURE OF CHEMICALS IS IMPORTANT IN ALL PROCESSING

There are several systems for making colour prints from negatives. They vary in cost and one of them, although technically easy, needs special equipment. The process below was chosen as a balanced method.

In light
1 Mix the chemicals and bring them to temperature in the processor. With Photocolor II you must add the print additive. Set up the other equipment for printing: you will find it easier if you make a list of times and temperatures to follow.

There are certain safelights for colour negative printing but they are so dim you will be better learning to work in the dark.

In total darkness
2 Place a sheet of paper on the easel and make your exposure. You can usually tell which side of the paper is the emulsion if you moisten your fingers and rub the paper between them: the emulsion is slightly stickier. Load the paper into the drum, facing in.

3 Preheat the drum using warm water and place it in the processor. Drain the drum. (1 minute at 40°C)

4 Pour in the developer and place the drum in the processor. The chemicals are not released until the drum is horizontal, so this is when you start your clock. Start to drain drum 10 seconds before time. (2 minutes at 34°C)

5 Add the stop-bath or clean water. (20 seconds at 34°C)

6 Pour in the bleach fix. As long as you observe the minimum time, the timing is not critical. Pour out and preserve. (1 minute at 34°C)

7 Remove the print from the drum and wash it in running water. This should be for a minimum of 3 minutes; it is better if the water is around 34°C. While the print is washing you should carefully wash and dry the drum.

8 Squeegee surface water off the print and hang it up to dry. You can play a hair dryer set to *warm* on the print to expedite drying. Because of the number of variables it is unlikely you will get a perfect print the first time. You should not make any assessments of colour or exposure until the print is dry.

Small variations in temperature can be allowed for in processing times. See the individual instructions.

1

2

3

4–6

7

8

PRINTING FROM COLOUR TRANSPARENCIES

The chemicals used for making prints from transparencies must be handled with great caution. There are three different systems for making prints from colour transparencies: Kodak Ektachrome 14RC, Ilford Cibachrome and Agfachrome Speed. They differ in price, process times and process cost. Agfachrome Speed is the newest and easiest to use. Paper for making prints from transparencies normally has a recommended filtration for different makes of film, which should be set initially.

In light
1 Prepare the chemical. The temperature range is 18–24°C. Place the transparency in the enlarger upside down (shiny side down).

In total darkness
2 Focus the image and set the recommended filtration. Because of the total darkness you may have some difficulty in identifying the correct side of the paper to use. The dark side of the paper which needs to be used is slightly shinier, which you can identify by feel. Make the exposure. If you make a mistake and expose the white side you can still use the paper; switch off the enlarger and turn the paper over.

3 Place the paper in a tray with the un-exposed (white) side up or in a tank with the white side facing in, then add activator. ($1\frac{1}{2}$ minutes at 18–24°C)

In light
4 Wash the paper in running water. (5 minutes at 18–24°C; $1\frac{1}{2}$ minutes at 18–24°C for tests)

1

2

3

4

COLOUR FAULTS

All of the faults encountered in colour processing and printing, with the exception of print exposure, are caused by carelessness. When processing films or paper you must adhere closely to the recommended temperatures and times: excess in either will cause over-development and the opposite will cause under-development. It will help to avoid mistakes if you make a time-table card that you can easily read. If you cover a grid with clear self-adhesive film you can use your wax pencil to make the notes on it.

Make sure that all your measures are really clean before use. Tiny quantities of the wrong chemical can irreparably damage your work. If there is any doubt about how clean the equipment is, it is safer to wash it again. Keep an accurate record of how often you use re-usable chemicals. Exhausted chemicals will not give satisfactory results.

Colour negative faults

Under-/correctly/over-exposed negatives: this is caused by setting your camera or flash for the wrong ASA speed. If you have checked this, your meter may be faulty and it should be checked.

(1)*Under*/(2)*correct*/(3)*over-developed negatives:* incorrect time or temperature during processing.
(4)*Complete film clear:* chemicals used in the wrong order.
(5)*Insufficient bleach fix:* this can be rectified by returning the film to fresh bleach fix.
(6)*Fogging:* the film has been exposed to light. Make sure your darkroom is light-tight.

Colour print faults

Wrong filtration: The cause of any overall colour cast is likely to be wrong filtration. Many people have slight problems with colour vision which may result in a colour cast. If people remark that your prints are always a strange colour, have your colour vision checked. With colour negative printing you add filters of the colour you wish to tone down (see p. 111).
Under/correct/over-exposure: you must use a test strip to evaluate the correct exposure.
Under-development: the print has a blue cast. This may be a time or temperature fault often caused by failure to pre-heat the drum.

Very pale: if your print is very pale and indistinct, the paper was the wrong way up in the easel. It must be discarded. If you moisten your finger tips you will notice a difference between the feel of the two sides of the paper.
Blotchy: if the print has been partially developed in patches the paper was the wrong way in the drum. The emulsion must face into the drum to get the full effect of the chemicals.

7 8 9 10 11

Transparency faults

(7)*Under*/(8)*correct*/(9)*over-exposure:* this can be caused by setting your camera or flash for the wrong ASA speed. If you have checked this, your meter may be faulty and it should be checked.

(10)*Under*/(11)(*dark–correct–light*) *first development:* this could be caused by incorrect time or temperature.

Contaminated colour developer: make sure that all containers are thoroughly cleaned. Colour-code your measures and containers, and always use them for the same chemicals.

Transparency print faults (Agfachrome Speed)

Wrong filtration: the cause of a colour cast is likely to be wrong filtration.

Under/correct/over-exposure: you must do a test strip etc.

Low/high contrast: the activator can be hardened with potassium bromide to decrease contrast, or diluted to increase contrast.

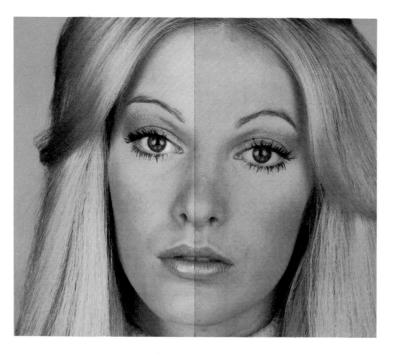

High contrast/Low contrast.

BLACK AND WHITE DEVELOPING AND PRINTING

There is a wide range of black and white films, developers and fixers in the shops. The process below is a guide only to the steps: times, temperatures and dilutions must be taken from the manufacturers' instructions. Times are normally only a few minutes and the temperature is normally 20°C.

In total darkness:
1. Load the film in the tank.

In light:
2. Mix the chemicals and bring them up to temperature in the bowl. Make sure you mix up enough for the film you are going to process.
3. Pour in the developer and start your clock. Tap the tank on a hard surface to dislodge any air bubbles. Agitate for 15 seconds and then 3 times every minute. Replace the tank in the bowl of warm water between agitations. Ten seconds before time drain the developer. In some cases it can be used again.
4. Pour in the stop-bath; this arrests the developer. After 30 seconds pour the stop-bath away.
5. Pour in the fixer. Agitate for half the recommended fixing time. Pour out the fixer and preserve.
6. Connect the washer and wash the film for at least 10 minutes. If your water supply is less than 15°C or you have no running water, nearly fill the tank with water (15–20°C) and agitate the tank 5 times. Change the water and repeat but agitating 10, then 20 and finally 30 times.
7. When the wash is finished add a few drops of the wetting agent to the water; this reduces the risk of drying marks. Then fix a clip to the end of the film and withdraw it from the spiral. Hang the film up with another clip on the bottom to pull it straight.
8. Moisten your film squeegee blades and remove any surface water from the film in one even movement.
9. When the film is completely dry cut it into lengths and store it in a negative wallet.

The choice of place to dry the film is important. The wet film is very vulnerable to dust and touch.

There are two secrets to successfully developing a film. The first is the accurate control of the *time*, the *temperature* and your *agitation*; the other is cleanliness. The first will consistently give you correctly developed negatives. The second should prevent the contamination of one chemical by another with a resultant spoiled film.

There are many types of developer that give different results. Initially use a general type recommended by your retailer; as you become more confident try other developers for extra fine grain or perhaps higher contrast results. An acid hardener fixer will give your negatives extra protection. Liquid chemicals are easier to make up than powders.

Developing a film

1

2

3–5

6

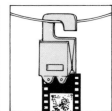
7

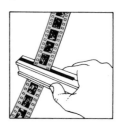
8

9

Because black and white paper is only sensitive to blue light you are able to have special light, called safelight, in your darkroom. This means you are able to find your way around more easily and can watch your print as it develops. There are few experiences in photography as rewarding as watching your own print appear in the developer. As with other processes, you must be careful with timing and temperature control.

The times for black and white processing can differ, depending on the makes of paper and chemicals. Check the instructions. Most processing is carried out at 20°C.

1. Mix up the chemicals.
2. After carefully cleaning your negative place it in the enlarger. Frame and focus the image. Make the exposure.
3. Place the paper in the developer. To give even development tilt the dish so that the developer runs to one end before inserting the paper; when you lower the dish the tidal wave effect will cover the paper. Gently agitate throughout the development. The paper should be left in for the full developing period, even if it is going too dark. This indicates over-exposure and must be rectified at the enlarger. The developer temperature can be maintained by placing its dish in a larger dish containing water at 22–24°C.
4. Drain the print and transfer to the stop-bath. This will arrest the developer and prolongs your fixer's life.
5. Drain the print and transfer it to the fixer. For efficient fixing you should gently agitate the dish for half the fixing time. Don't let any fixer contaminate the developer: it will totally neutralize it.
6. Wash the print for the recommended time and dry it. Before hanging it up squeegee off any surface water.

Be careful how you handle the print with tongs: plastic papers can be easily scratched. Use separate gloves for developer and fixer. Do not touch the paper with damp or chemically-contaminated fingers.

Black and white papers

There are two main types of black and white paper, resin-coated (RC) and fibre-based. Whilst fibre papers will give a richer print they take up to 40 minutes to wash and are difficult to dry without expensive equipment. RC or plastic-based papers can be washed in 10 minutes and always dry flat. It is best to hang them on a length of line.

Black and white papers of varying grades are designed to change the contrast in imperfect negatives by increasing or decreasing the number of grey tones between black and white.

A *soft* paper, Grades 0 and 1, has more grey tones for printing contrasty negatives. A *hard* paper, Grades 3 and 4, has fewer grey tones for printing negatives with low contrast (*see* p. 122). Most prints should be done on *normal* paper of Grade 2.

By using colour filters when printing, Ilford Multigrade RC paper has a range of 5 grades within the sheet, which means you need to buy only one box of paper for all your printing requirements. If you have a colour enlarger simply use the yellow and cyan filters; with ordinary enlargers you can purchase a set of suitable filters for Multigrade.

Making a print

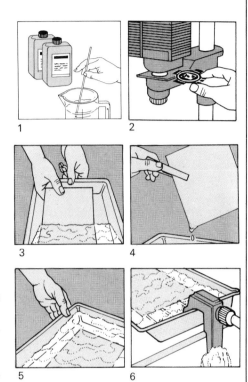

1 2

3 4

5 6

Grade 1 (soft).

Grade 4 (hard).

BLACK AND WHITE CONTACTS AND CROPPING

It is not often that you want to print all the pictures on a film, so to decide which ones are best you need to make a contact print of the negatives – a print of the whole film with each picture the same size as the negative. You can then examine each picture and experiment with cropping as well. A 36-exposure 35mm film will just fit on a 10″ × 8″ sheet of paper, though 12″ × 10″ is more convenient.

Contact sheets

1. Mix your chemicals and bring them up to temperature. Grade 1 paper or Multigrade will give you a better result.
2. Switch on your safelight and switch off your main light. Switch on the enlarger, set the lens to its maximum aperture and adjust the height, so that the focused beam will cover your paper size; if you mark the enlarger column you need only do this once. Then switch off the enlarger.
3. Lay a piece of paper, face or shiny side up, on the baseboard and lay out the negatives with their shiny side up. Cover with a sheet of clean glass to flatten the negatives.
4. Make a test strip (*see* opposite), process it and make your exposure.
5. Number your negatives and contact sheet for filing.

The contact sheet
Use a clean sheet of glass to flatten the negatives.

Cropping

The contact sheet gives you positive pictures to work with. You will need a wax pencil, some sort of magnifier and two pieces of black card cut to an 'L' shape. Start by looking carefully at each picture, putting a little X by each one that you like. Now study each of these under the magnifier, looking especially at focus and distraction in the background. When you have narrowed the choice down to 3 or 4 pictures, use your two L's as a variable frame to experiment with different picture-shapes. Mark suitable shapes on the contact sheet.

Cropping

BLACK AND WHITE TESTING AND PRINTING

You can buy exposure-measuring devices for use in the darkroom, but the more normal means of establishing the correct exposure is to make a small print with several exposures on it. This is called a test strip and can be used when making contact prints as well as ordinary prints. As with your camera, the lens on your enlarger has f stops for controlling the aperture. Your test strip should consist of a series of doubled exposures that will also equal stops.

The negative.

Test strip

1. Set up your darkroom and chemicals for printing with the safelight on and the white light off.

2. Put your negative in the enlarger. A focusing aid will enlarge a tiny portion of your negative, even the film-grain. Stop down the lens two stops: this creates a small depth of field for accuracy.

3. With the red safe filter across, place a quarter of a sheet of paper on the easel. Switch off the enlarger and remove the red filter. Expose the whole sheet for 5 seconds then cover a quarter of it with the cardboard and expose for a further 5 seconds. Cover half the sheet and expose a further 5 seconds. Cover half the sheet and expose for 10 seconds. Cover three-quarters and expose for 20 seconds. The sheet has now four exposure-bands: 5, 10, 20 and 40 seconds. For a contact sheet work in thirds of 3, 3 and 3 seconds, giving 3, 6 and 9 second exposure bands.

4. Process as normal for the full time and, having made sure your box of paper is safely closed, examine under the white light. If all the bands are very dark stop down the lens more. If they are all too light you can open up one stop. If it is very light increase your times to 10, 10, 20 and 40, which will give you 10, 20, 40 and 80 on the strip.

Your test strip will also give you a final check on the suitability of the negative and your choice of paper grade.

The test strip.

The print

Having examined the test strip you can decide on the correct exposure. Set this on your timer and switch off the white light. Switch on the enlarger, check the focus and the framing, then switch off the enlarger, take a sheet of paper and make your print. Process this as before.

It is a good habit to always check that your box of paper is closed before switching on the white light. Wash and dry your print.

The final print.

BLACK AND WHITE PRINT MANIPULATION

The advantage that black and white printing has over colour printing is the ease with which you can lighten or darken areas for greater emphasis. This is termed 'dodging' when you lighten and 'burning-in' when you darken a specific area. You can do it to reduce background distraction or simply to emphasize your subject. Dodging and burning-in are the art of black and white printing. You have seen from your test strip that with more exposure your print will be darker and that with less it will be lighter. These two techniques are simply the controlled use of more or less exposure to specific areas of the print.

Dodging

If an area of your print is too dark you can lighten it by shading the area from the light source for part of the exposure. Experiment to find by how much; your test strip will help. If your exposure is 20 seconds but you want to lighten similarly to the previous band, you need to dodge for 10 seconds of the exposure. When you want to dodge at the edge of the print you can use your hand or a piece of card, but this will not be selective enough in the middle: a small length of stiff wire with a disc of cardboard or lump of Blutac will be best (Blutac may be shaped to suit irregular areas).

Burning-in

Burning-in is the opposite effect: you give extra exposure to a specific area which appears too light in your first print – this is often used with flash pictures where your subject is very light. You can use your hands, but this is a difficult technique to master and you will have more success if you cut an irregular hole in a piece of card. Three cards with different size holes will suit most needs.

With both these techniques the secret is to keep the tool moving, avoiding any hard edges. It will take a little experience to get proficient so do not be disheartened if your early results are disappointing.

Basic print
Although the subject is properly exposed, the background is too light in the top left corner.

Final print
'Burning-in' (giving extra exposure) the top left corner has balanced the background.

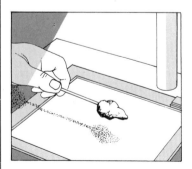

Dodging.

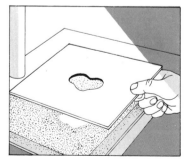

Burning-in.

Vignetting
Printing through a hole in a piece of card which is moved slightly during the exposure gives the soft edges to a vignetted print.

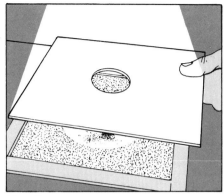

Vignetting.

Vignetting

It can be very attractive to give pictures of people an old-fashioned look where the picture has no hard border but simply fades away towards the edges. This is called vignetting and its principle is the same as with burning-in.

Set up to make your print as normal. Cut an oval or circular hole in a piece of card which you will hold between the enlarger and the paper. Put your paper in the easel and with the red safe filter across, switch on the enlarger to position your mask. Switch off the enlarger, remove the filter and make your exposure. Be sure to move the mask slightly during the exposure to avoid a hard edge: the amount you move the mask will determine how faded the edge is.

Photograms

You can make pictures called photograms using simply the enlarger. By arranging objects with a definable shape on a piece of photographic paper under the enlarger and turning it on, you make a print of their silhouettes.

Plan your photograms before you go into the darkroom. Try arranging your objects on a sheet of white paper until you find a pleasing shape or pattern, then use a pencil to draw round the outlines to act as a guide when you are in the darkroom. Set up to make a print but with no negative in the enlarger. Put a sheet of paper in the easel and, with the red safe filter across, switch on the enlarger. Using your sketch as a guide arrange your objects, then make an exposure. You want to get a good black when the print is developed and you may need to experiment a few times to get the correct exposure.

Small household objects like scissors, needles and thread, paper doilies and glass ashtrays are fun to start with, but you can use almost anything that is not too high.

Photogram
Everyday subjects can be used to make interesting photograms.

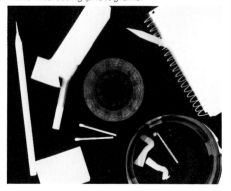

BLACK AND WHITE FAULTS

To make a good print you need a good negative. And you should strive to achieve results similar to the picture in the middle. If your results are similar to the others you must rectify your technique. Different grades of paper as marked will help you print difficult negatives.

UNDER-DEVELOPMENT

Under-exposure (Grade 4).　　Correct exposure (Grade 4).　　Over-exposure (Grade 4).

CORRECT DEVELOPMENT

Under-exposure (Grade 3).　　Correct exposure (Grade 2/3).　　Over-exposure (Grade 3/4).

OVER-DEVELOPMENT

Under-exposure (Grade 1).　　Correct exposure (Grade 0/1).　　Over-exposure (Grade 2/3).

Negative faults
Exposure or processing faults could be caused by any of these factors.

Exposure problems
Wrong ASA set
Wrong flash settings
Dead batteries
Wrong camera settings
Wrong metering technique

Under-development problems
Too short a time
Too low a temperature
Not enough agitation
Exhausted or too-dilute developer

Over-development problems
Too long a time
Too high a temperature
Too much agitation
Developer not diluted correctly

Negative faults

Fogging: film exposed to light before being developed and fixed.

Insufficient developer: make sure you have mixed enough chemicals for the type of film and tank.

Fogging.

Insufficient developer.

Stress.

Touching.

Air bubbles: air bubbles have prevented the developer reaching the film. Tap the tank to dislodge bubbles after pouring in the developer.

Stress: the film has been bent when loading the spiral. Do not force film on to the spiral.

Touching: the spiral was wrongly loaded and one loop of the film touched another, preventing development.

Reticulation: one chemical was far too hot or cold, causing expansion and contraction.

Reticulation

Although impossible to see unless greatly enlarged, the negative has broken up into minute irregular particles.

Print faults

Shake: the enlarger-base or column was not stable and the enlarger moved during the exposure.

Finger prints: fixer on the fingers has contaminated the paper.

Uneven illumination: the light from the enlarger was too weak at the edges. This may be caused by using the wrong condenser in the enlarger.

Paper flatness: the paper was not kept flat in the easel.

Shake.

Finger prints.

Uneven illumination.

GLOSSARY

A

Agitation Movement of photographic chemicals during processing to ensure even coverage.

Aperture The opening in the lens, fixed on simple cameras but adjustable on others, that controls the amount of light reaching the film.

Aperture priority camera Automatic 35mm camera on which the user selects the aperture and the camera sets the appropriate shutter speed.

ASA (American Standards Association) Measurement of a film's sensitivity to light. The higher the ASA the faster, or more sensitive, the film.

Auto-loading camera Camera that automatically takes the film on to the winder spool.

Auto-focus A camera or lens that focuses automatically using either sonic, infra-red or contrast comparison.

Available light Any light other than that added by the photographer.

B

Backlight button *See* Exposure Compensation.

Bean bag Semi-soft camera support for use on uneven surfaces.

Bellows A close-up accessory, mounted between the lens and the camera, that gives a wide range of magnification.

Bounced flash A method of getting a softer, more diffused light from a flash gun by bouncing the light off a white wall or ceiling on to the subject.

Bracketing Method of ensuring correct exposure by taking several pictures of the same subject with a range of settings.

Burning-in Giving extra exposure to a small area of a print.

C

Centre-weighted meter A form of camera light meter that reads light from the whole subject, but gives more emphasis to the central area.

Colour cast Overall colour fault on a picture.

Colour head Enlarger light source with built-in colour filters for colour enlargements.

Colour negative film Film which gives only colour prints.

Colour transparency film Film which gives colour slides for projection or viewing. Prints can be made from these slides, but the process is expensive. Also known as *Reversal film*.

Complementary colour The primary colour remaining after the other two primaries have formed a secondary colour.

Contact sheet Positive print of the whole film, the same size as the negatives, that is used for assessment and selection.

Cropping Altering the shape and size of a picture for better compositional effect.

D

Darkroom Light-proof room or area for processing and printing film.

Darkroom timer Means of controlling exposures made with an enlarger. Usually coupled to the enlarger.

Daylight film Film designed for use in daylight, or with electronic flash or blue flash bulbs.

Dedicated flash A flash unit designed to function with a particular camera and to utilize some of its controls.

Depth of field The area in front of and behind the point of focus that will be sharp at any given aperture.

Develop Turn the latent image on the film into a metallic silver image.

Developer Chemical for developing film.

Developing tank Light-tight container for developing films.

Disc camera Small automatic snapshot camera with the film in the shape of a disc.

Dodging Curtailing the exposure of a small area of a print.

E

Emulsion The light-sensitive material that is coated on different bases to make photographic film or paper.

Enlargement Any print larger than the negative used to produce it. The term is more commonly used to denote a print bigger than an *En-print*.

Enlarger Used to project a negative or transparency onto a sheet of photographic paper.

En-print Standard-sized print made on $3\frac{1}{2}''$ wide paper from any popular negative size.

Exposure The combination of the time for which light is allowed to fall on a film and the intensity of that light. The time is determined by the *shutter speed*, the intensity by the *aperture* setting.

Exposure compensation Some means of over-riding the camera's built-in metering system.

Eye-piece correction lens Optical lens that screws on the viewfinder to correct the image for spectacle-wearers.

Fill-in Flash or reflector used to lighten the shadows in a picture.

Film speed The sensitivity of a film to light. Films are given ASA (*see* ASA) numbers which denote their speed. The higher the ASA, the more sensitive the film.

Fix Remove all undeveloped light-sensitive silver salts to make developed film stable in light. *See* Fixer.

Fixer Chemical used to dissolve all undeveloped silver salts in a film.

Flash guide number Number which provides a guide to the correct exposure when using flash.

Focal length The effective distance from lens to film, measured in millimetres. The primary classification of lenses is by their focal length. Long focal length gives a narrow *angle of view*, reduced *depth of field*, and increased *subject size*. Short focal length gives a wide angle of view, increased depth of field, and reduced subject size.

Grain Metallic silver particles in film which form a visible photographic image when the film is exposed and developed.

Hot-shoe Automatic flash coupling fixed to camera.

Landscape format Pictures taken with the camera held horizontally.

Latent image The invisible image on a negative made up of activated silver salts before development. *See* Develop.

Macro Used frequently to indicate the ability of a lens to focus closely. True macro means a magnification of greater than 1 : 1.

Matt Card with a window cut in it for mounting photographs.

Montage A picture made up by pasting parts of several pictures together.

Multimode camera 35mm camera which offers a choice of up to six different exposure systems, or 'modes'. These usually include *aperture priority*, *shutter priority*, *manual*, and *automatic*.

Negative Developed photographic image in which light areas in the subject appear dark, and shadows appear light. It is usually made on a transparent base, so that an image with normal, positive tones can be printed by exposing sensitive paper to light which passes through it.

Over-exposure The result of giving the film excessive *exposure* to light. Produces a weakening of colour, or a lightening of tones in black and white pictures.

Paper grades The range of black and white paper to allow the satisfactory printing of difficult negatives.

Photofloods Very powerful photographic light bulbs.

Photogram Picture created in the darkroom using photographic paper and the silhouettes of household objects.

Portrait format Pictures taken with the camera held vertically.

Primary colour One of the three colours, red, green or blue, that make up white light.

Print A positive enlargement from a negative or transparency.

Processor Integrated drum and temperature-controlled water bath for processing colour prints.

Props Anything added to a photograph other than the main subject to enhance it.

Reversal film Film designed to produce a positive result directly from exposure and processing, without a negative. *See* Colour transparency film.

Safelight A red or orange light designed for using in a darkroom when printing *black and white* pictures.

Sandwiching Combining two or more negatives or transparencies to make a composite picture.

Secondary colours Yellow, magenta or cyan, formed by mixing any two primary colours.

Self-timer Clockwork or electronic means of delaying the exposure for about 10 seconds after pressung button.

Shutter System controlling the amount of time light can act on a film.

Shutter priority camera Automatic 35mm camera on which the user selects the shutter speed and the camera sets the appropriate lens aperture.

Shutter speed Amount of time (usually measured in fractions of a second) for which a camera shutter remains open, allowing light to act on the film.

Silver salts The light-sensitive part of a film that records the picture as a latent image.

Slide Positive image produced on transparent film for projection on a screen. Also known as a transparency.

SLR (Single lens reflex) Camera which allows the user to see the exact image formed by the picture-taking lens, by means of a system of mirrors between lens and film.

Soft focus Photographs taken using some form of diffuser in front of the lens to soften the image.

Supplementary lens Additional lens attached to a camera's *normal lens* to provide a different focal length.

Tele-convertor An optical attachment that, when fitted to the back of a lens, increases its focal length.

Telephoto lens Lens of long *focal length* which enlarges distant subjects within its narrow *angle of view*.

Test strip Enlargement using progressive exposures for assessing the correct exposure.

Tripod Three-legged camera stand used when it is important to keep the camera steady.

TTL (through-the-lens) metering Light metering system using light-sensitive cells within the camera body to measure light which has passed through the lens.

Tungsten light Artificial light source using a tungsten filament contained within a glass envelope.

Tungsten film Colour film suitable for use with *tungsten light* sources.

Under-exposure The result of giving a film insufficient exposure to light. Produces a darkening of the image.

Wide-angle lens Lens of a short focal length, which gives a wide angle of view.

Zoom lens A lens with variable focal length that allows it to fulfil several functions.

Credits

Equipment on p. 25 by courtesy of Percival Cameras of Woolwich; Diorama on p. 81 by courtesy of Beattie's of Holborn. Photographs:
Heather Angel: p. 34 top, p. 74 bottom left, p. 78, p. 86 top left
David Bailey: p. 84, p. 85
Bruce Black/*Camera Weekly*: p. 35 top
Peter Cook: p. 35 bottom right
Tony Evans: p. 8 left, p. 75 top, p. 76
Foster's Lager/Joe Partridge: p. 52
Terry Hewitt: p. 31 bottom, p. 35 bottom left
Diana Holmes Johnson: p. 67
George Hughes: p. 9 bottom
Michael Langford: p. 6 bottom, p. 41 top, p. 43 top, p. 46, p. 48
Patrick Lichfield: p. 70, p. 71 top
Eamon McCabe: p. 34 bottom, p. 64, p. 65
Brian Mumford: p. 54 top (both), p. 59 centre
Richard Sharpley: p. 66 centre
Anthea Sieveking: p. 56 bottom, p. 57, p. 58, p. 59 top, p. 60, p. 63, p. 69
Southbound Travel/Joe Partridge: p. 53
Spectrum: p. 40 centre
Tony Stone: p. 55, p. 61, p. 62, p. 77
Woman's Own/Joe Partridge: p. 7 bottom
Woman's Realm/Joe Partridge: p. 68 top, p. 82 top, pp. 88–90
Steve Wright: p. 66 centre
Yorkshire Television: stills by Ken Loveday: p. 6 top, p. 7 top, p. 8 right, p. 9 top (both)

ACKNOWLEDGEMENTS AND FURTHER READING

Acknowledgements

I would like to thank George Hughes for being fun to work with, both as the Editor of *Camera Weekly* and as co-presenter; Graham Watts, Peter Cook, Michael Langford, the contributors and all the production team at Yorkshire Television for making life so easy when filming and in the studios; Janet James and Gill Gibbins at Collins Publishers; and once more the many people in the photographic industry who have helped me over the years – in particular Gene Nocon of The Photographers' Workshop; Martin Walters and Carol Davies of Canon; Liz Royal and Phil Lawrence of Kodak; Tony Lavender of Ilford. I would especially like to thank Sally Mason of Yorkshire Television for helping me navigate the shoals.

Further Reading

Heather Angel. *The Book of Nature Photography*. Ebury Press.
Michael Langford. *The Step by Step Guide to Photography*. Ebury Press.
Michael Langford. *The Book of Special Effects Photography*. Ebury Press.
Michael Langford. *The Darkroom Handbook*. Ebury Press.
Alex Morrison. *Photofinish*. Michael Joseph.
The Kodak Colour Printing Guide. Patrick Stephens.

INDEX